A World of Their Own

Twentieth Century British Naïve Painters

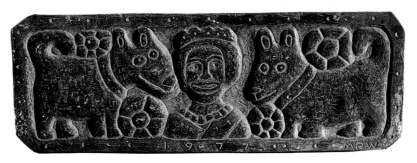

Mabel Pakenham-Walsh *Two Corgis* slate carving

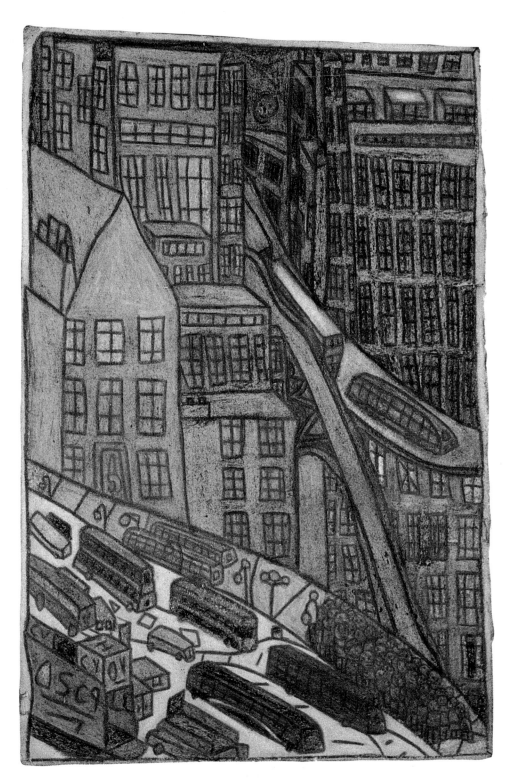

Anthony Miller *Town Centre* 1967

A World of Their Own

Twentieth Century British Naïve Painters

Jill and Martin Leman

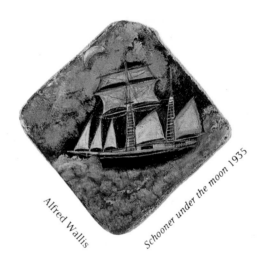

Alfred Wallis *Schooner under the moon 1935*

Pelham Books

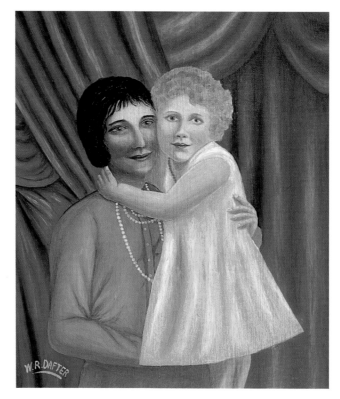

William Dafter *Mother and child* 1971

First published in Great Britain by Pelham Books Ltd,
44 Bedford Square, London WC1B 3DP
1985

Leman, Martin
A world of their own: twentieth century naïve painters
I. Title II. Leman, Jill
759.2 ND468.5.P74
ISBN 0 7207 1609 8

Typeset by TNR Productions, London N7
Printed in Italy by Arnoldo Mondadori, Verona

Introduction

During the last few years there has been a growing world-wide interest in naïve paintings and the artists who produce them. In the United States and Europe, major public galleries have sections specially for them and there are open exhibitions and awards to encourage artists. In Britain, too, there is an increasing awareness: the 1984 Summer Exhibition at the Royal Academy devoted a whole room to naïve paintings and the 1985 Spring Exhibition, 'St Ives, 1939-64' at the Tate Gallery included two naïve painters, Alfred Wallis and Bryan Pearce.

Naïve artists, whether or not they have had formal training, are outside the current movements and fashions of the fine art world. Their paintings are created out of love, even obsession, for their subjects. They present a fresh and startling perception – often of a visionary or dream-like quality – of the world. Scottie Wilson summed it up, when he said: 'It's a feeling you cannot explain. You're born with it and it just comes out. That's you, and that's all about it.'

Many artists dislike the terms 'naïve' and 'primitive' to describe their work, which is often of great visual subtlety and sophisticated design. But the other terms for this genre – folk, popular, Sunday painters, self-taught artists, etc – are equally unsatisfactory. If one thinks of 'naïve' as describing the straightforward and honest quality to be found in these paintings, and 'primitive' as the direct response that they arouse in the viewer, then perhaps the terms are more acceptable.

The artists and their work have been placed in chronological order in this book. For the earlier ones – Alfred Wallis, Ralph Crossley, C.W. Brown – painting was something they did in their spare time or took up on retirement. Now, however, many of the younger generation – Beryl Cook, John Allin, Andrew Murray and others – have been able to earn a living as professional artists. Their work has also been available through books, magazines and greetings cards to a much wider public than was possible before.

If Alfred Wallis had not been 'discovered' by Ben Nicholson and Christopher Wood in 1926, it is doubtful that any of his paintings would have survived for posterity; today there are exhibitions – local and national, large and small – for artists to exhibit in. But because primitive painting is outside the mainstream of the modern art world, it is still difficult for many artists to find a wider audience. In this book we have not been able to include all the artists we know who are painting in Britain today, and there are many more as yet undiscovered. We hope this book will be an encouragement.

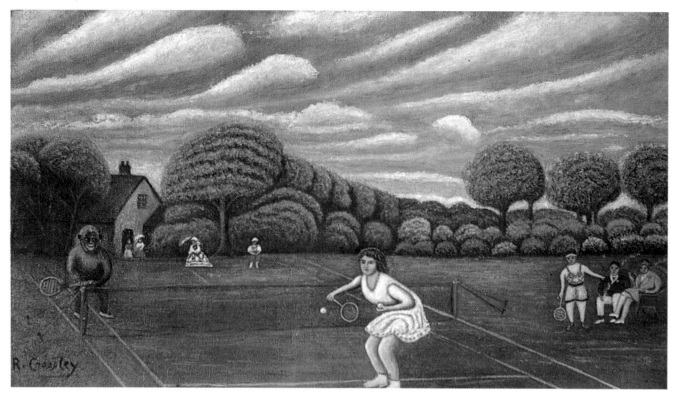

Ralph Crossley *Game of Tennis* 1937

The authors would like to say a special thank you to the following for their invaluable help
in providing some of the material for this book:

The Artists.

George Murray, Artist and Collector of Naïve Art.

Eric Lister, Lionel Levy and Jess Wilder of the Portal Gallery, London.

We should also like to thank:
The Tate Gallery, London; City Museum and Art Gallery, Stoke-on-Trent;
Glasgow Museum and Art Gallery; Gimpel Fils Gallery, London;
Henry Gilbert of the Wills Lane Gallery, St Ives, Cornwall; Stanley Harries of RONA;
Sheldon Williams; Mrs Mary Pearce; Mr and Mrs J. Frankson;
Sally Pasmore; Ron McCrindell and Peter Silver.

The Artists

Alfred Wallis

1855–1942

Alfred Wallis was born in Devonport, near Plymouth, on 18 August 1855, while his father, a master paver by trade, was away fighting in the Crimean War. His mother came from the Scilly Isles and died when he was young. The family was very poor: Alfred never went to school and at the age of nine went to sea as a cabin boy. He spent sixteen years working on ships fishing Newfoundland waters.

In about 1875 Wallis married Susan Ward, a widow twenty-one years his senior, acquiring a family of five step-children and a home in Penzance. Susan bore him two daughters both of whom died as babies. After a year or so, Alfred left deep-sea fishing and became an inshore fisherman with the Newlyn and Mousehole fleets. In 1890, at the age of 35, he gave up fishing and moved with Susan to St Ives where they had a marine scrap business which prospered, enabling him to retire in 1912 and buy a house with his savings at 3 Back Road West.

In the following years Wallis did a few odd jobs – he was the first person in St Ives to make and sell ice-cream on the streets. Susan was a forceful and likeable woman, a Salvationist, and she and her children dominated Wallis's life. After her death in 1922, Wallis was lonely and began to paint 'for company'. St Ives has always been a place for artists, and the fact that Wallis lived near the St Ives Gallery and could see artists working around him was probably an encouragement.

In 1928 the artists Ben Nicholson and Christopher Wood came across Wallis's cottage and saw him working at a table. Nicholson bought a painting – *Schooner and lighthouse* – for 2s 6d (12½ pence) and kept in touch with Wallis by letter when he returned to London. Their meeting and subsequent relationship was of mutual benefit: the support and encouragement of the two artists was just what Wallis needed, and in turn he had a refreshing influence on their work. His pictures became known to Nicholson's London friends, among whom were Herbert Read, Barbara Hepworth and H.S. Ede, whose collection of paintings by Wallis can be seen at Kettles Yard, Cambridge.

Wallis made a point of saying that he never went out of the house to paint. This was a distinction he made between himself and the trained painters in St Ives: they painted what they saw, he painted from memory. Usually he painted on cardboard from the local grocer; these pieces were not always regular in shape so he would make the design of his picture fill the board. Wallis worked flat on the table, making a kind of chart of his painting, and often viewing a scene from several different points in the same picture. He used marine or household paint in brown, black, grey, white and green. A story is told about Wallis that when a visitor asked him why

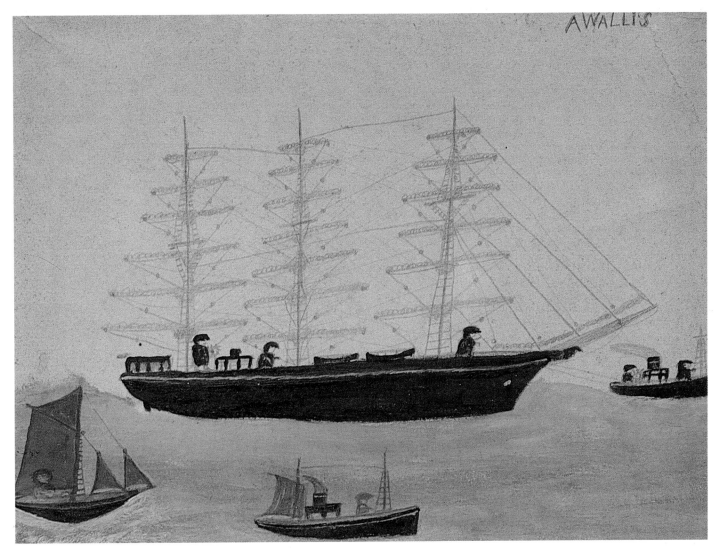

Alfred Wallis *Untitled*

he painted the sea white rather than blue, Wallis filled a tumbler with water and showed the visitor that water is colourless or white.

In June 1941, when Wallis was eighty-five and could no longer look after himself, he was taken to Madron workhouse in Penzance, where he spent the last months of his life. He died on 29 August 1942.

Wallis's artist friends arranged that Bernard Leach should design his grave stone in Barnoon cemetery, St Ives. It shows a little man with a stick climbing up to a lighthouse. The inscription reads: 'Alfred Wallis, Artist and Mariner'.

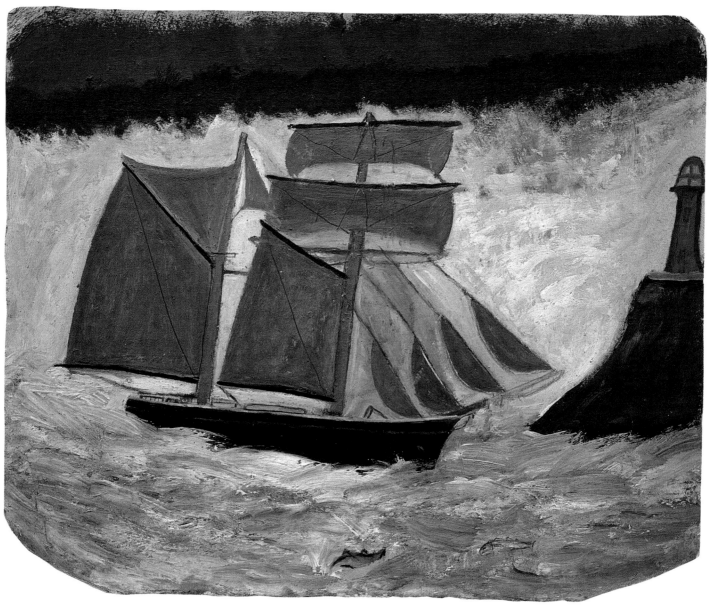

Alfred Wallis *Schooner*

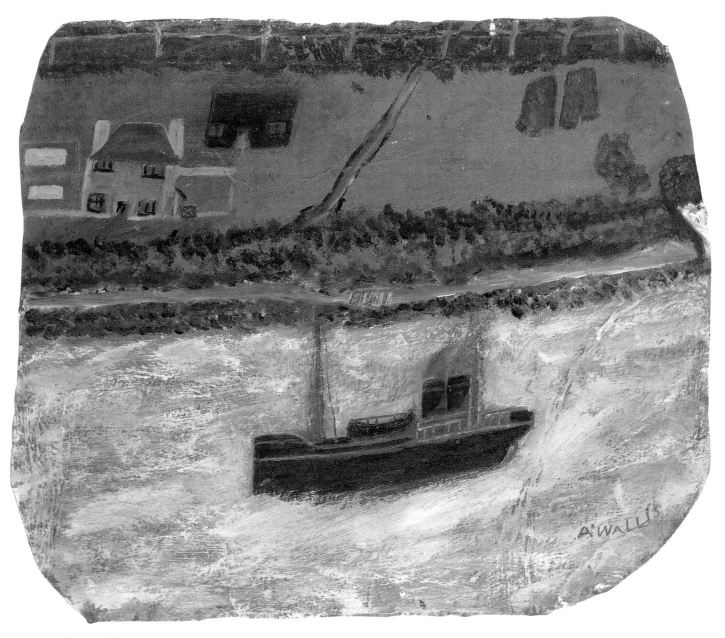

Alfred Wallis *Untitled*

C.W. Brown

1882–1961

At school C.W. Brown had a reputation for being 'an outstanding pupil', which he attributed to his fear of the cane, for both his father and headmaster were strict disciplinarians. As a child, he earned money for his family by selling newspapers and home-made oat cakes in the Staffordshire village where they lived. When he was twelve years old, he went to work for a local farmer for 1s 6d (7 pence) a week, plus his keep. He was so miserable that he ran away after a month to become a miner for 1s 8d (8 pence) a day. The next year, in January 1895, many miners lost their lives in a flooding disaster at a nearby pit; afterwards, boys of 13 and under were banned from working underground and C.W. Brown had to give up his job and return to the farm. He became a miner again two years later, studying hard, and eventually became colliery manager in 1923. Resigning from this job over various policy disagreements, after some unsettled years he took a position at a North Staffordshire pit in 1931 and remained there until retiring in 1948. He married in 1901, and with a few short interruptions lived all his life at 14 Lord Street, Etruria.

C.W. Brown recalled that, 'even as a boy of thirteen, working as a hired farm boy, I used to make panoramic sketches of the area', and later he did the same down the mine. Art was always his main hobby, but in retirement he started to keep a diary in which he recorded his thoughts and reminiscences. Although he exhibited locally, he never achieved the recognition he felt he deserved, and he did not like or understand the term 'primitive' applied to his work. G.V. Bemrose, the Curator of the Stoke-on-Trent Art Gallery, persuaded him against attending art classes, saying 'Whatever you do, forget that idea; for if you do, you will lose your one great asset which is "instinctive art", and original. There is too much convention in art; stick and carry on as you are doing.'

C.W. Brown used black ink and wash or watercolours until the age of seventy-four, when he changed to oil paints.

He left more than a thousand works to the City Museum and Art Gallery, Stoke-on-Trent, where they were shown in retrospective exhibitions in 1969 and 1979.

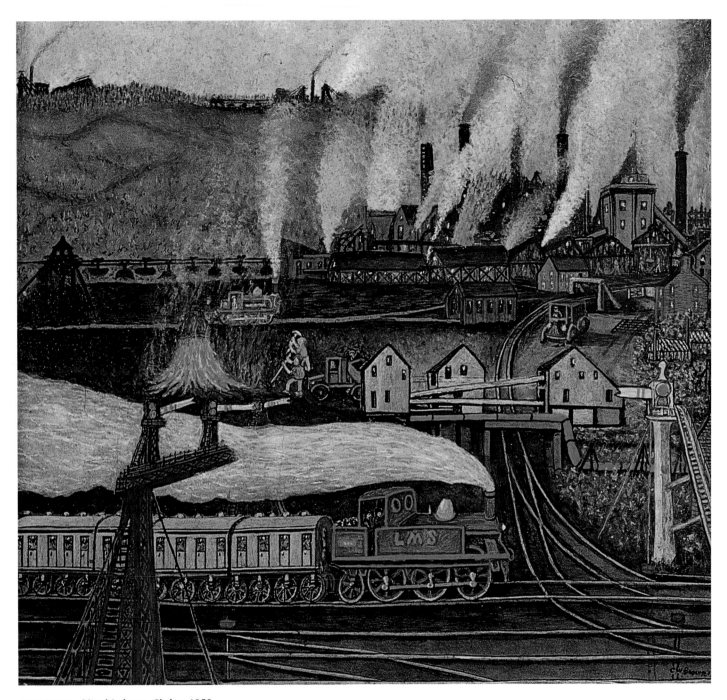

C.W. Brown *Mixed Industry, Shelton* 1958

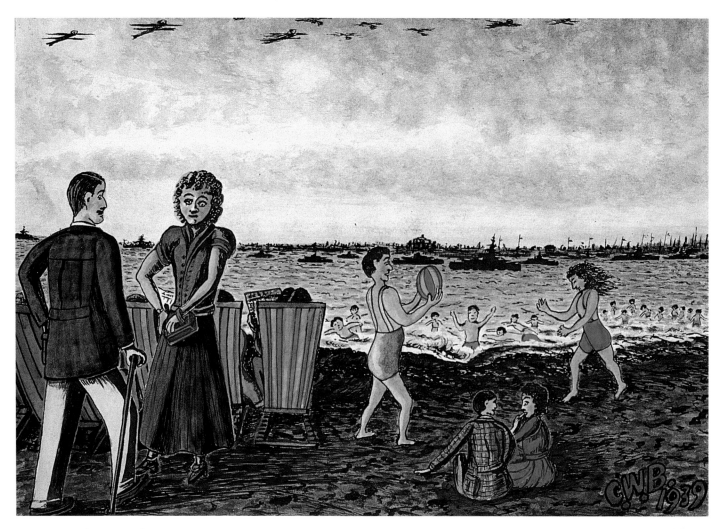

C.W. Brown *The Coming of War* 1939

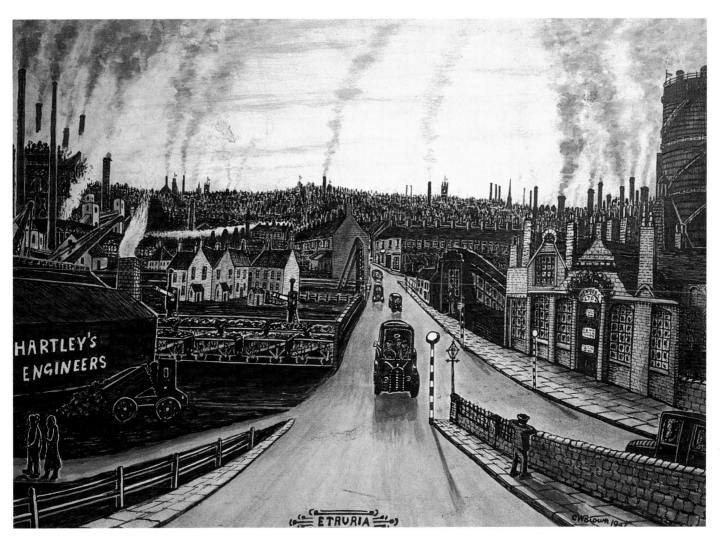

C.W. Brown *Etruria* 1947

Ralph Crossley

1884–1966

It is entirely due to George Murray (the artist Jerzy Marek, *see page 82*) that Ralph Crossley's paintings have survived. When George Murray lived in Preston, he discovered the few remaining paintings and managed to piece together the following information from conversations with people who lived nearby and remembered him.

Ralph Crossley was born in Yorkshire, and was one of a family of ten. He was particularly fond of his sister Lottie whose portrait he painted (on the back of the painting he wrote 'My sister, her soul has a fortnight's notice to find a new tenancy'). His working life was spent as a bricklayer.

After his wife died in 1936, he became a recluse and always answered the door with the chain on, letting no one into the house. Although he was financially well off (one of his brothers left him £40,000), he used only the kitchen of his large detached house and he even had a bed there. Neighbours said he slept in his clothes and shoes. When a neighbour lent him a portable radio he returned it a few days later saying, 'You can have it back now, I've finished painting it.' Crossley's neighbours did not think much of the paintings they saw, saying of a Crucifixion that 'Christ was too large for the cross'. In another painting of some girls in a field with horses, 'the girls were twice the size of the horses'. He gave some portraits he had painted to some local children, but they did not like them and sold them at a local jumble sale. Crossley often painted pictures with sporting themes – boxing, bowling, tennis and ice-skating. He probably got his ideas from items he read in newspapers: his painting of a girl playing tennis with a gorilla was inspired by *King Kong* in 1938. He used oil paints on canvas.

Crossley worked on his paintings almost obsessively and liked to talk about them. From 1938 to 1945 he exhibited pictures in the open show at the Harris Art Gallery, Preston. The curator, Mr Pavior, liked his work and Crossley once donated the gallery a large sum of money.

At one time George Murray owned eight of Crossley's paintings; he thinks there may be others in the Preston area.

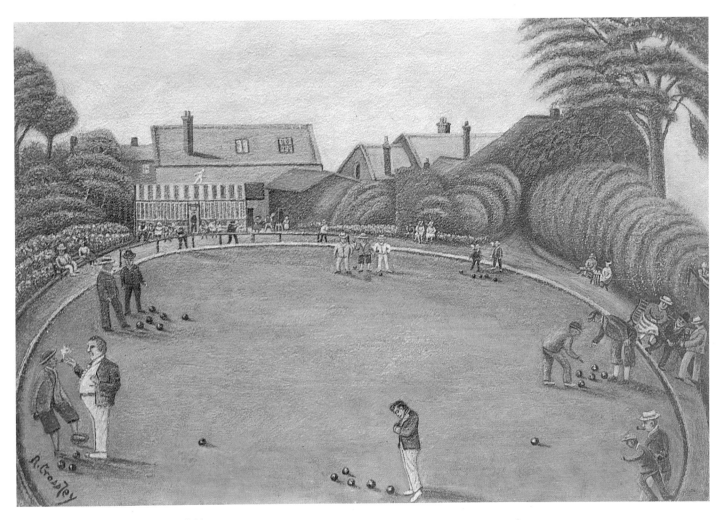

Ralph Crossley *Bowling Green, Mayfield*

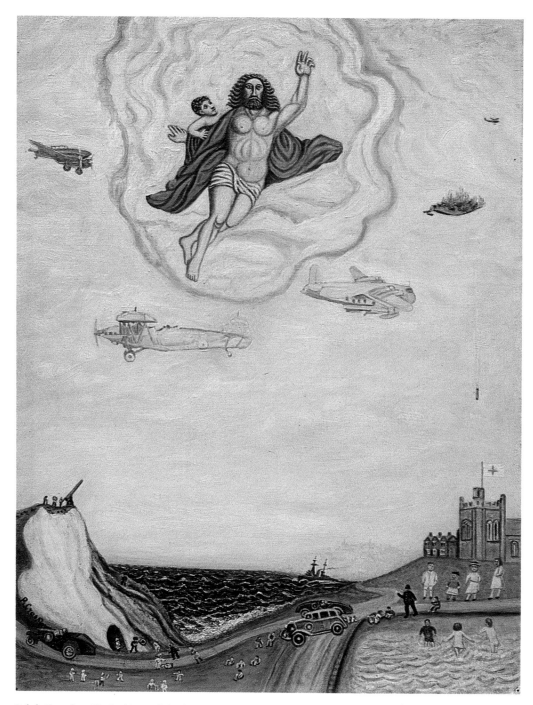

Ralph Crossley *The Problems of the day* 1943

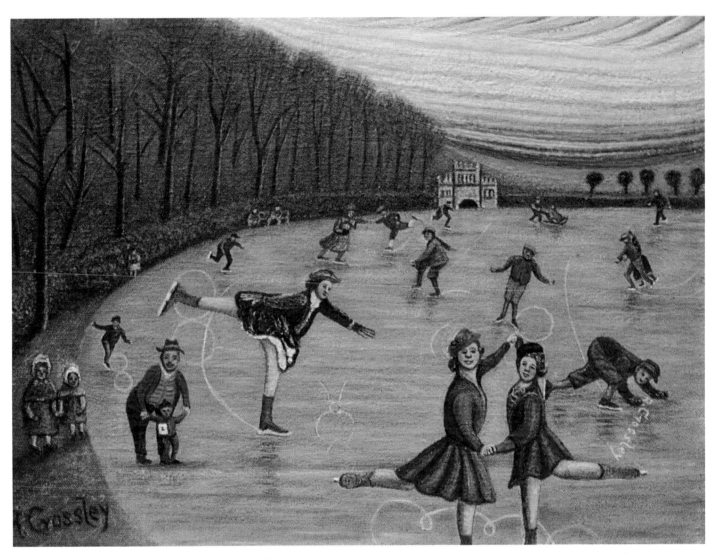

Ralph Crossley *Skaters*

L.S. Lowry

1887–1976

Laurence Stephen Lowry was brought up in Rusholme, a suburb of Manchester, and educated at Victoria Park School. He attended private painting classes in Manchester, and later studied art at the Municipal Art College. After moving to Salford with his parents, he also went to classes at Salford School of Art, and continued to do so occasionally until he was thirty-eight.

An only child, L.S. Lowry was protected by his parents from the harsh realities of life and, although free to come and go as he pleased, he never travelled far from home. After his parents died (his father in 1932 and his mother in 1939), he moved to a house in Mottram-in-Longendale where he lived and worked alone.

Lowry's work was discovered in 1938 by A.J. McNeill Reid, the senior partner of the Reid and Lefevre Gallery in London. Reid saw some of Lowry's paintings at a framer's, and immediately contacted the artist. Within a year Lowry had a highly successful exhibition at the London gallery. Lowry's one regret was that his mother was not alive to enjoy his success.

In 1952 Lowry had an exhibition with the Crane Gallery, Manchester, the first commercial gallery outside London to show his work. Further exhibitions were held in 1955 and 1958. Later, as the Crane Kalman Gallery, it showed his work in London.

In 1962 L.S. Lowry became a Royal Academician. The Arts Council organized a travelling retrospective exhibition of his work which was shown in Sunderland, Manchester, Bristol and the Tate Gallery, London, in 1967 and the same year the Post Office issued a Lowry stamp, a reproduction of a mill scene. During the early seventies Lowry did not paint much and exhibited mainly in the Royal Academy Summer Show.

Lowry took an interest in the work of other naïve artists: he bought a painting of some cows by James Lloyd and he opened two of John Maxwell Nithsdale's one-man shows in Manchester.

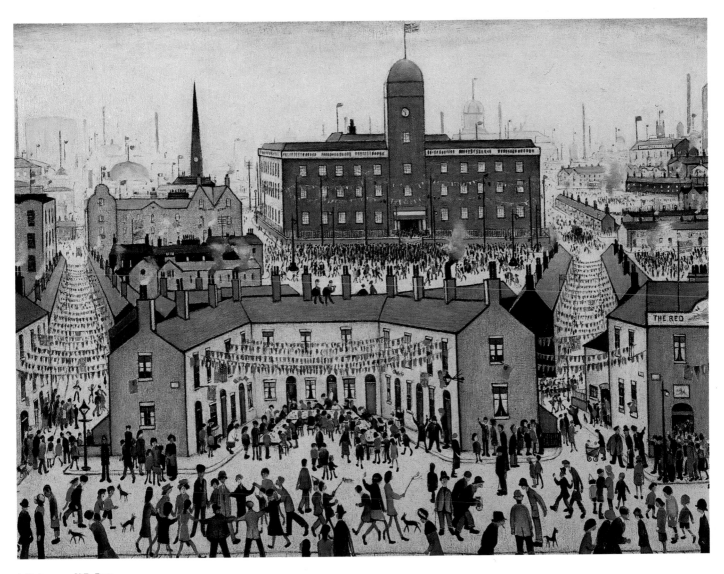

L.S. Lowry *V.E. Day*

Scottie Wilson

1890–1974

Robert 'Scottie' Wilson came from a poor family in Glasgow, where his father was a taxidermist's assistant. Scottie had very little education as he ran away from school when he was nine and earned his keep selling papers on the street. Little is known of his early life except that he was in the army before the First World War, and after military service in the East Indies, he bought himself out in South Africa to join the Merchant Navy.

Eventually Scottie settled for a time in Canada and spent the years between the wars there. At first he moved about the country as a general trader; later he had a small shop in Toronto where he sold cut-glass novelties and bought up old fountain pens to strip the gold from the nibs. With plenty of pens available, Scottie began to doodle on the cardboard top of a table he had in the shop. Two days later the table top was completely covered in complicated designs. When a friend saw the table and congratulated him on the work, Scottie bought drawing pads and coloured pencils and soon drawing became his main interest.

At first Scottie gave his work away; but in order to make a living, he liked to set up his paintings in disused shops or cinema foyers and charge admission rather than sell them. When he returned to England in 1945, he put on a show of his work in an old wall-paper shop in Scarborough, and in a dance hall in Aberdeen. In 1947 he was persuaded to have a one-man show in the Gimpel Fils Gallery in London; his reputation grew and from that time he exhibited regularly in leading galleries in Paris, Belgium and Basle. His works were acquired by the Museum of Modern Art, New York, Musée de l'Art Moderne, Paris, and the Tate Gallery, London.

However, despite his success, Scottie often sold his pictures on the street for £1, to the dismay of the West End galleries where his pictures were on sale for £250.

Scottie dressed in the style of a music-hall caricature of a working man, in cloth cap, muffler and boots; when he had the money he would have his clothes made in Savile Row. He was a cheery character and his broad Glaswegian accent was a familiar sound in the Mayfair galleries where he would call in for a chat and a drink. In the 1960s he was commissioned by Royal Doulton to paint designs on plates, and these have since been exhibited at retrospective exhibitions with his paintings.

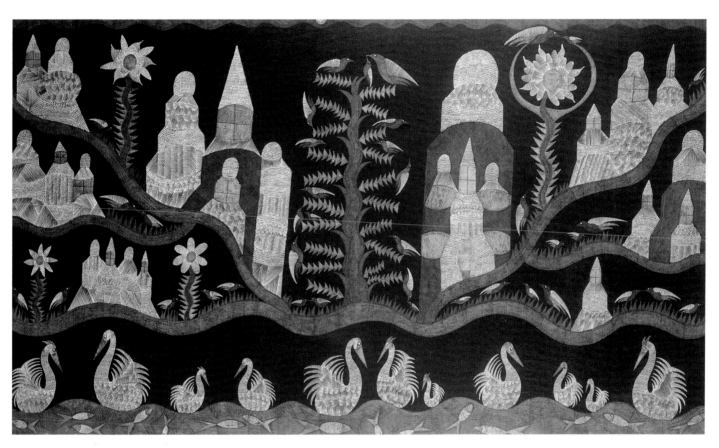

Scottie Wilson *Untitled*

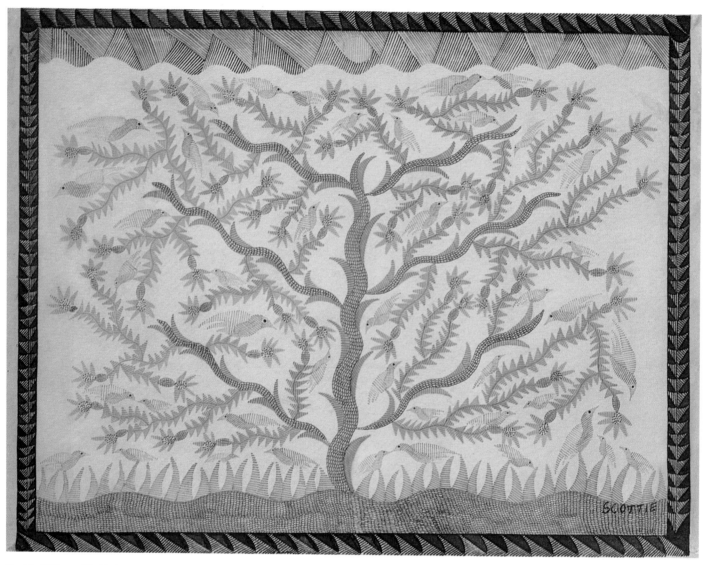

Scottie Wilson *Untitled*

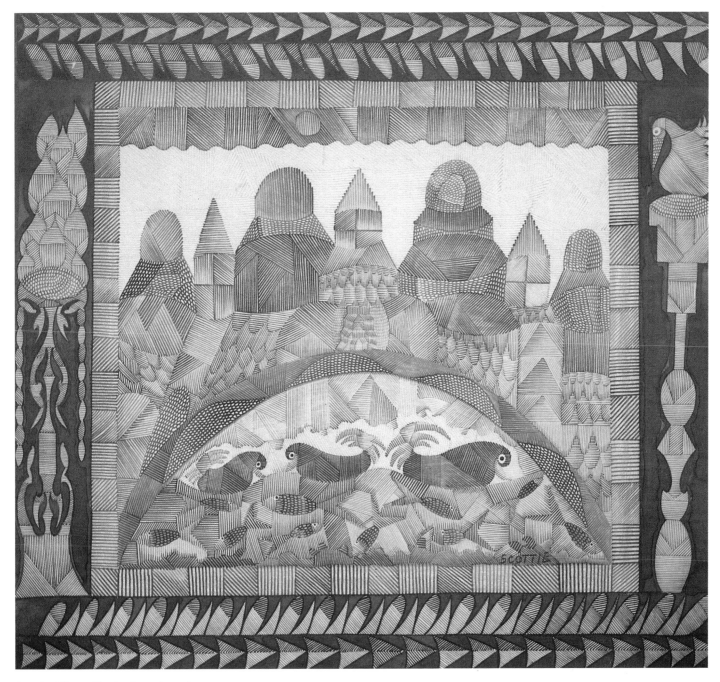

Scottie Wilson *The Castle on the Bridge*

Martin Kulsen

1891

Martin Kulsen was born in Harlingham, in the Netherlands; he left school when he was eleven and went to work for a carpenter, but later became a sailor. He first went to sea in 1905 – still in the days of sail – on a Dutch fishing vessel. During the 1914-18 war, he was in the Dutch Merchant Navy; since the Netherlands was neutral, he became a blockade runner for both sides. He was still in the navy during the Second World War; when the Netherlands was occupied by the Nazis in 1940, his ship sailed to a British port and came under the Admiralty's control.

Martin Kulsen survived shipwreck three times: once by mine and twice by submarines. In 1943 on the last occasion, he spent eight days in a lifeboat before he was rescued. Because of the injuries he had received he was discharged from the navy on medical grounds.

Settling in Islington, London, Martin spent some twenty years working as a messenger for an insurance company. He only took up painting in 1982, at the age of ninety-one, when he had to give up his hobby of carpentry, because neighbours complained about the noise he was making.

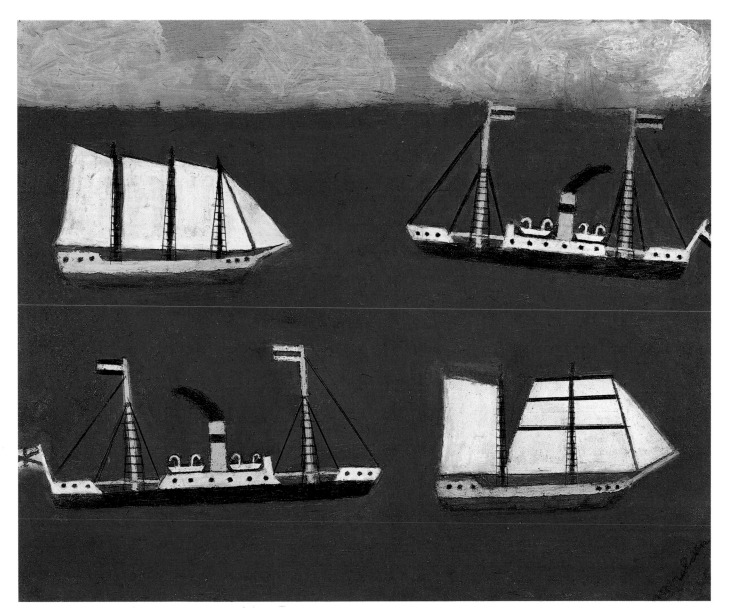

Martin Kulsen *Sail and Steam*

Margaret Baird

1891–1979

Margaret Baird painted her first picture when she was seventy-four years old: to amuse her grandson she painted a cat scratching its claws on a tree. Although the picture was roughly painted on an odd bit of hardboard, Margaret's daughter and son-in-law, George Murray (the painter Jerzy Marek), saw it and encouraged her to try another painting. The next picture Margaret did showed three children (her brother, sister and herself), sitting on a very large horse, surrounded by farm animals. It was exhibited in Manchester and bought by Andras Kalman, well-known collector and dealer in naïve paintings.

Most of Margaret Baird's paintings were done in the years 1966-74. She worked for a few hours during the day, two or three days a week. She would 'dream' about the picture she was going to paint until it was quite clear in her mind, and then she would start the painting. Many of her pictures were of childhood memories, but she also like sporting themes such as cricket or horse-racing.

Her vision of the world had no place in it for the realities of life. She once painted a cattle market, and when her friend, Gladys Cooper, also a painter, pointed out that the bull in the picture should have 'things' below his belly, Margaret replied that she would not put them in as they would spoil the picture. Margaret Baird and Gladys Cooper lived only thirty yards from each other in Preston, and often went on tours to Scotland together. After one such trip they each painted a picture of a place they had visited; naturally both pictures were very different, and the two nearly quarrelled over which painting was right – they were each astonished at the other's inaccuracy.

Margaret worked at a table by the window in her sitting room. Using oils, she painted directly on to board, working from top to bottom. The sky always came first, except in her sporting pictures, when she would put in the grass first; when it had dried, she would paint the figures. From her first picture she never required any tuition in technique: she was very good at adapting the brush-strokes in her paintings to show that the grass was velvet smooth, the side of a house rough-cast, or the sky turbulent. When she had finished a painting, her brushes looked like brooms with the hairs spread out in all directions.

Andras Kalman bought all Margaret Baird's paintings from her first show in Manchester, in 1966. The Arts Council gave her a one-man show in Edinburgh and she exhibited at the Crane Kalman Gallery, the Portal Gallery and the Grosvenor Gallery in London.

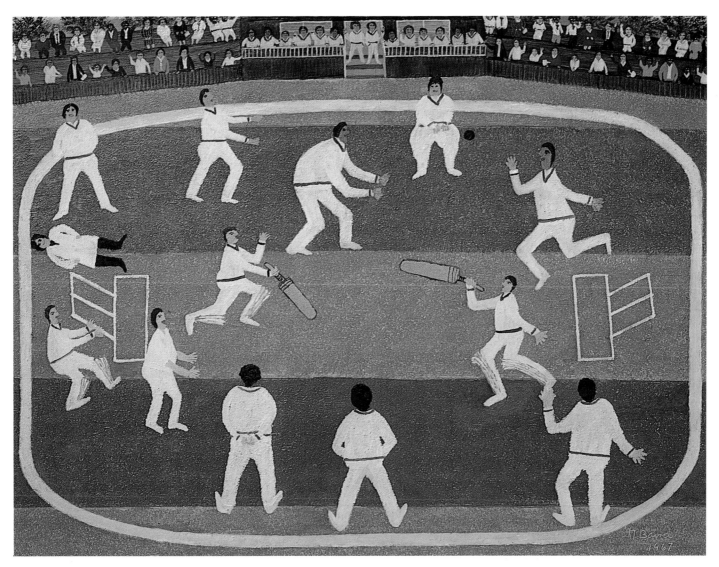

Margaret Baird *Cricket Match* 1967

George Pinder

1894–1983

George Pinder's father, a journeyman tailor from Dublin, met his mother at her father's farm in Derbyshire. When they married they moved to Manchester, where George was born. His father died at an early age, leaving four children, and his mother then worked in the local mill until eventually she re-married.

Unhappy at home since he did not get on with his stepfather, George joined the army in 1911; when the First World War began in 1914, he was in one of the first regiments to go to France. Later he was taken prisoner at Mons, one of the few to survive the battle.

When George Pinder retired at the age of sixty-six, he decided he must have a hobby; as art had been his best subject at school, he enrolled in an art class at the local Adult Education Centre. However, he did not like the way he was taught, and resolved to develop his own style and ideas. He became so involved that he would get up at six o'clock and do two hours painting before going to his part-time job.

He always used oil paints, painting directly on to canvas; his subjects were mainly landscapes or interiors which often included animals or people.

George Pinder's paintings have been shown in mixed exhibitions in the North and in London.

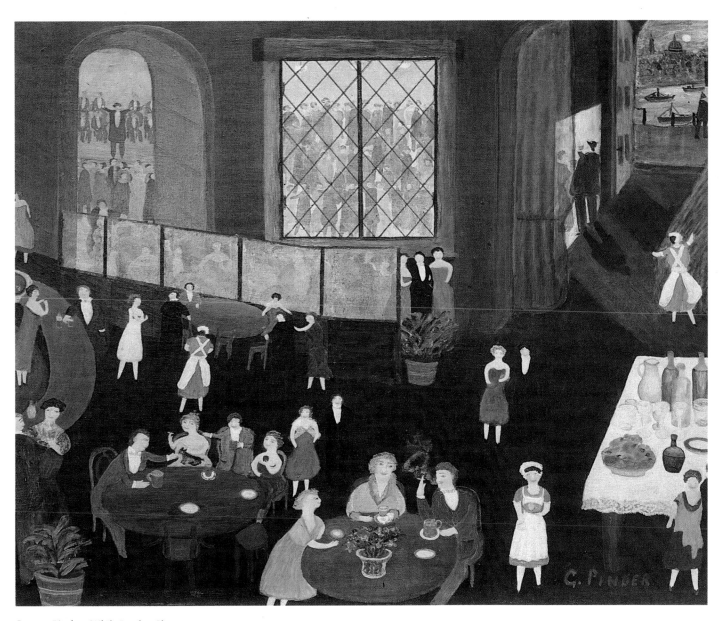

George Pinder *While London Sleeps*

A.W. Chesher

1895–1972

As a boy in Bedfordshire, Chesher worked on his father's farm and became fascinated by the steam traction engines in use at that time. He was thrilled at the age of sixteen to be allowed to drive one and he knew every different type of engine. His passion for steam agricultural machinery remained with him throughout his life.

Chesher was forced to retire in his mid-forties, as the result of two tragic accidents: his gun back-fired when he was shooting crows one day, causing him to lose an eye, and shortly afterwards he caught his arm in a threshing machine, resulting in almost total disability on one side. Fortunately, he turned to painting in order to record the usage and details of the steam engines; he had a photographic memory and steam traction enthusiasts were amazed by his accuracy. He even made models of the engines to get the correct perspective in his paintings.

In twenty-five years Chesher painted about 300 pictures making a unique and complete history of British steam farm machinery. He felt that while steam trains had been well documented only he had bothered with the machines he called 'monsters'. Often Chesher would include himself as a boy or young man in his paintings. Each painting he produced had an explanation of the scene written on the back: for example, *Quite a load* (*opposite*) shows the Fowler Road Locomotive, which had broken down on its way through Bedfordshire, being hauled to the nearest railway station by a local farmer using his steam threshing machine.

Eric Lister, of the Portal Gallery, knew A.W. Chesher and has described him as 'the definitive English countryman; he spoke with a soft Bedfordshire accent and always wore heavy tweeds, a cloth cap and sparkling black boots'.

A.W. Chesher's pictures are greatly prized by steam-engine enthusiasts, and also by people who love his nostalgic and colourful views of Bedfordshire.

He had five exhibitions at the Portal Gallery, London.

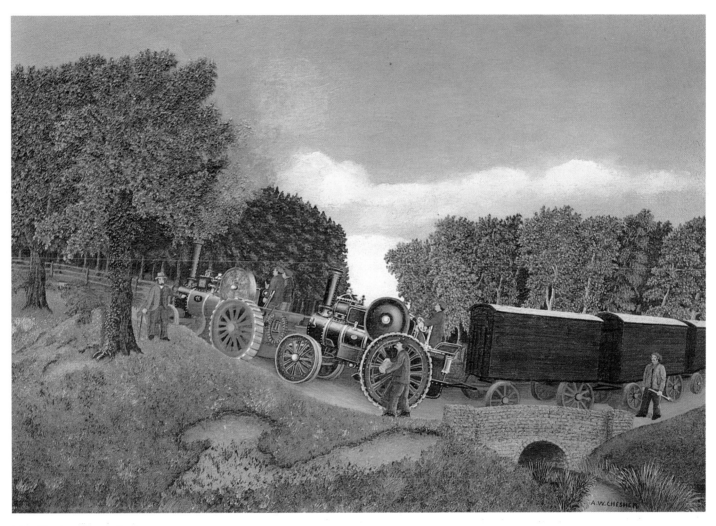

A.W. Chesher *Quite a load*

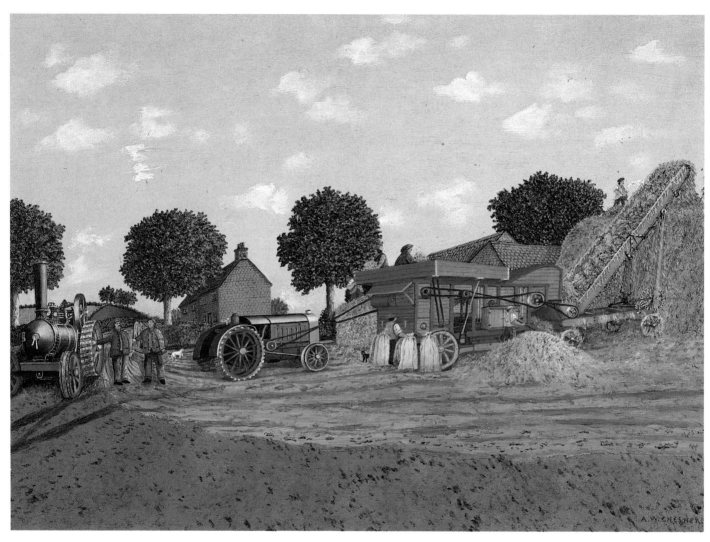

A.W. Chesher *Into the Thirties*

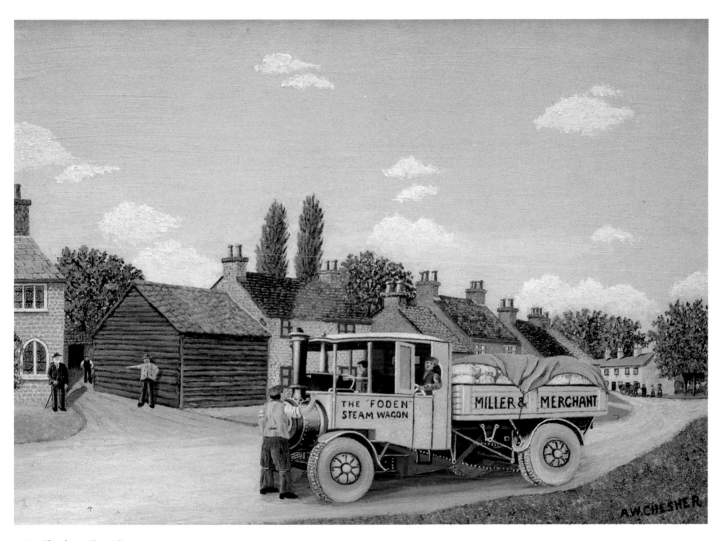

A.W. Chesher *The Miller's Wagon*

Gladys Cooper

1899–1975

At the age of fifty-two, Gladys Cooper joined an art class in Wigan held by Theodore Major, a well-known Lancashire artist. Realizing that she had talent, Major told her to paint in her own way and not to be influenced by his teaching of the other students. At the end of the lesson, he told everyone to paint a picture at home, and bring it the following week to show the class. As King George VI had just died, Gladys painted a funeral, showing lots of little graves with RIP on them, and some men carrying a coffin under their arms. When the paintings were shown to the class, Theodore Major exclaimed, 'Gladys is the only artist here!' Gladys, a wise lady and not easily flattered, did not take much notice of this remark and stopped going to the class. Three weeks later, Major saw her and said he wanted her to go on painting in her own way. He told her, 'You are what we call a modern primitive. It does not matter if people laugh at your paintings; take no notice of them.'

George Murray, who knew her well, describes her as a jolly lady, always smiling and full of fun. Since her friends used to pop in to visit her during the day, she usually painted at night on her dining-room table.

Gladys Cooper lived in Preston in a Victorian house full of her large paintings which were framed by her husband in strong box-like grey frames. She always used oil paint and would first work out the picture or part of it in a sketch book. She said she had never had a drawing lesson, so did not know much about perspective and shading, and couldn't draw people very well so that was why she often did back views. She told George Murray that she hated getting the paints and brushes out because she knew it meant hard work: 'At my age I get tired by evening and don't feel like painting, but once I've got them out, I get interested and can't stop. I don't really know why I paint.'

Gladys exhibited at the Grosvenor Gallery and the Portal Gallery in London.

Gladys Cooper *The Gate*

William Dafter

1901

When his father died in 1909, William, his brother and six sisters were put into a children's home. William had had little schooling, since his family had been constantly on the move. He was always good at drawing and can remember his first painting, a farmyard, which he did in the children's home one Sunday afternoon. The housemaster thought it was so good that he had it framed, and this made William want to be an artist.

After some time in the army, William Dafter worked as a sign writer. He painted ice-cream barrows – 'the old Italian ones with pictures all over them' – and these were his first works in oil. Now aged eighty-four, painting is his recreation.

Originally from Bethnal Green in London, William now lives in Blackburn, Lancashire. He paints at home, although he has to regulate his work a little as his wife does not like the smell of oil paint.

William Dafter did have an ambition to have a one-man show, but he has given so many paintings away that he has never amassed enough together; however, he has had paintings in many mixed shows in London and the North.

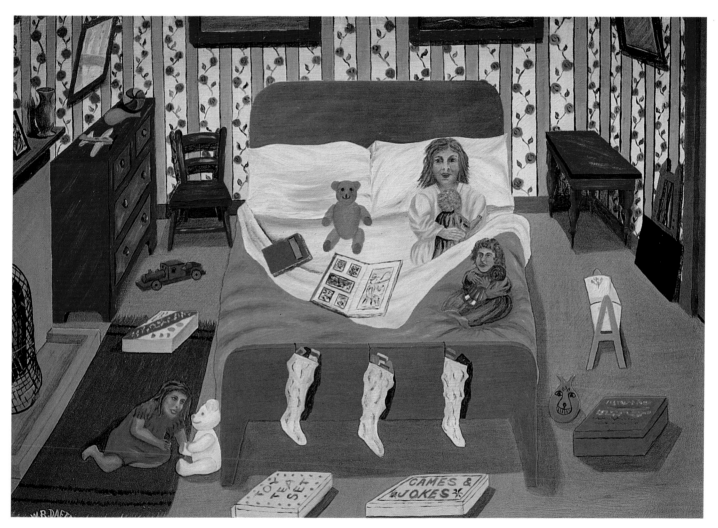

William Dafter *Christmas* 1971

George Smethurst

1902

George Smethurst left school at the age of twelve, and worked in a cotton mill in Dearnley, Lancashire. After four years on active service during the Second World War, he was employed in production control at a factory until he retired in 1966.

Although he used to do a little painting and drawing as a hobby, it was not until he retired that he began to paint pictures showing his impressions and memories of the Lancashire life of his youth. In 1974 he entered a painting of a Salford street scene in an open art competition and won the Harold Riley Award for the best original painting.

George has an excellent memory and when he paints a Lancashire street, he recalls the shops he used to visit as a child and the names of the sweets he bought with his Saturday ha'pennies – 'Knockout toffees, Everlasting strips and Wardle humbugs'. He also depicts scenes from his schooldays showing games like 'Peggy' and 'Knur and Spell' that children played sixty years ago. In his painting *Promenade in 1920* of the Central Pier, Blackpool, he shows workers from the Lancashire cotton mills on their annual 'Wakes Week' outing and enjoying 'a glimpse of a better life after fifty-one weeks at work'. As a young man, George remembers putting two shillings (10 pence) a week in a savings club to pay for his seven days' holiday.

In 1974, George met John Frankson, an art dealer, and his wife, Bertie, who arranged exhibitions for him in the North and in London. He has appeared on television to talk about his work, and some of his paintings have been reproduced as greetings cards.

George Smethurst has painted about three hundred pictures, many of which are now in private ownership around the world, including a painting of the late Gracie Fields's birthplace which was in her collection.

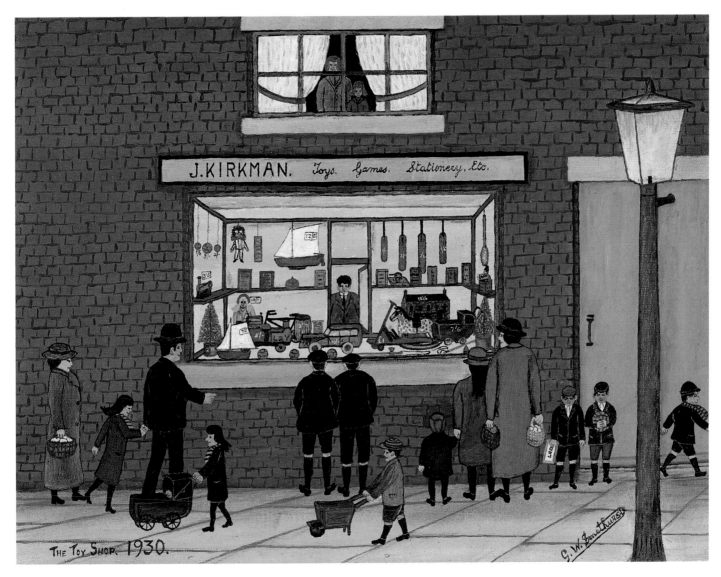

George Smethurst *The Toyshop in 1930*

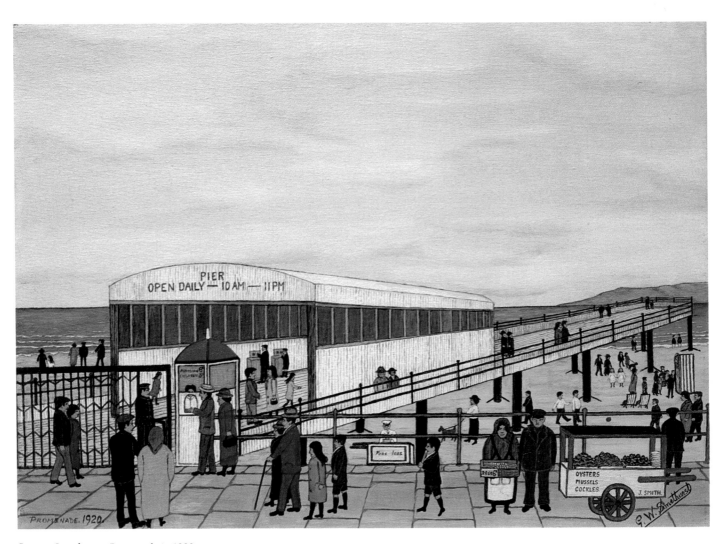

George Smethurst *Promenade in 1920*

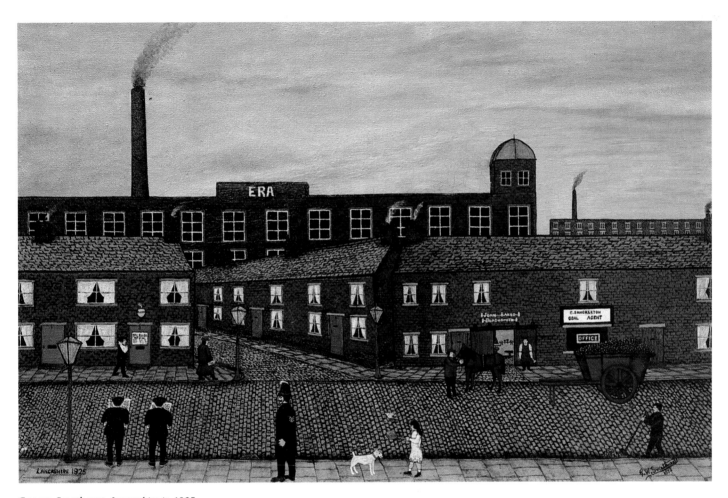

George Smethurst *Lancashire in 1925*

Frances Bond

1904–1978

Frances Bond was born in Newcastle-under-Lyme, but her family moved to Yorkshire when she was a baby. She was educated at a country school not far from her home near Wakefield, and left at the age of thirteen, during the First World War. Her father went into the army and Frances, her mother and three younger brothers moved to Bradford. Frances went to work in the woollen mills, where she stayed for sixteen years.

Frances met her husband Albert at a mission church, Princeville St Peters, in Bradford. They married in 1926, the year of the general strike. In 1934 their son was born, and Albert applied for and got a job as Superintendent at Paton and Baldwin's woollen mills in Shanghai, so the family went to live in China. During the Second World War the family had many adventures, not returning to England until 1951.

Frances took up painting in 1965: housebound through illness, she could not get out to buy her husband a birthday card; so using a small box of watercolours which they had in the house to amuse their grandson, she painted a river scene from a magazine that Albert had admired. Albert had the painting framed and it hangs in his bedroom to this day.

Frances then started painting with acrylic paints and very fine brushes. She sat in an armchair to paint, with her board resting on the arm of the chair, and her white cat, Zozo, would often sit on the chair back looking down at what she was doing. Frances very rarely mixed colours, preferring to use them straight from the tube. She had her own way of shading under the objects she wanted to stand out.

In 1967 Frances won first prize in a painting competition run by *The People*, and came to London to receive her award. BBC television made a film about her and some of her paintings were reproduced as greetings cards.

Frances Bond *Bourton-on-the-Water*

Albert Bond

1905

Albert Bond started work in a Yorkshire woollen mill when he was twelve years old – half the day was spent at the mill and the other half at school. At fourteen he became a full-time worker and went to night school and technical college to learn the worsted trade.

In 1934, Albert and his family moved to China where he had the job of Superintendant at Patons and Baldwin's wool factory in Shanghai. When Japan invaded China, the Bonds were evacuated to Hong Kong, but returned to Shanghai some three months later when the war had moved south. In 1941, at the time of Pearl Harbour, his wife and son left for Australia, but Albert remained behind and was interned by the Japanese. Reunited after four years, they returned to England in 1945. However, they went back once more to Shanghai and spent two years there before the families were again evacuated, this time to England in December 1948, when the Chinese Communist armies closed on the city. Albert Bond and his colleagues stayed at their factory under communist rule until 1951 when he obtained an exit visa.

In 1958 the Bonds settled at Galgate, near Lancaster, where Albert became sub-manager at the nearby mill. Inspired by his wife Frances's interest in painting, Albert also began when he retired in 1970. The painting reproduced here is one of a series which show silk being processed at Galgate mill; the original paintings were purchased by George Murray who presented them to Lancaster Museum.

Unfortunately, Albert has not had time to paint for the last few years due to the failing health of his second wife, Edith. Now that she is being well cared for at a nearby hospital, Albert hopes to take up painting once more: 'Eighty is a good time to start a new career.'

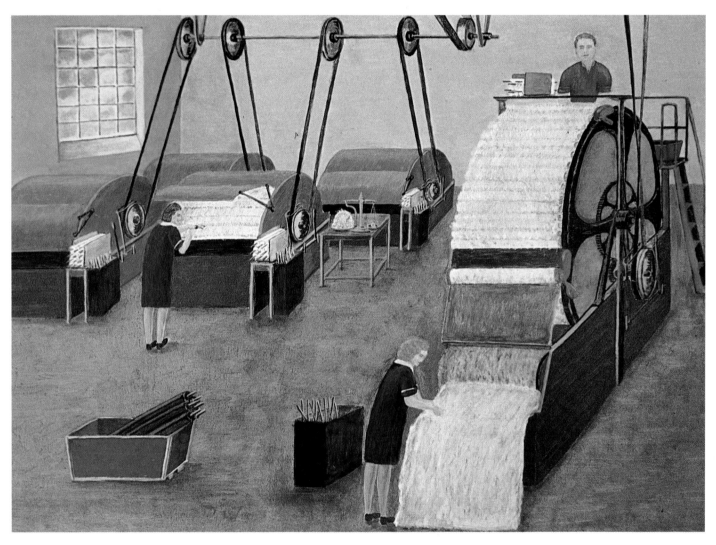

Albert Bond *Silk Dressing* 1973

James Lloyd

1905–1974

Although James Lloyd had always been interested in drawing, it was not until 1953, when he was forty-eight, that he began to paint. He was then working as a cowman and living with his family in a tiny cottage in Skirpenbeck, near York; that Christmas, he could not afford to buy cards and so he decided to make his own.

Lloyd's subjects were day-to-day country matters, inspired by photographs he saw in the *Yorkshire Evening Post* or the *Farmer's Weekly*. With watercolour paints and old paint-brushes discarded by his children, he would build up his pictures using hundreds of thousands of minute, coloured dots. He painted flat on the kitchen table with his family around him.

In 1956 his wife Nancy showed some of his paintings to an art gallery in York; the gallery took some of Lloyd's paintings, although they were so unusual. Nancy also contacted John Jacob, then Curator of York City Gallery, and Sir Herbert Read who lived in the area. Both men visited the Lloyds: Sir Herbert bought some paintings and John Jacobs promised to help if he could. The following year in Liverpool at the John Moores Exhibition, Jacobs met Robert Melville, who was associated with the Arthur Jeffress Gallery in London. Melville was able to arrange Lloyd's first one-man show at the gallery in London in 1958, when out of the thirty-two paintings in the exhibition all but two were sold.

Shortly after this success, James Lloyd took a job with easier hours in a factory and the family moved into a council house in the village. They acquired a television set and Lloyd painted the pop and film stars he saw on the screen as well as his country scenes and animals. He usually painted fifteen to twenty pictures a year.

In 1964 Ken Russell made a film called 'The dotty world of James Lloyd' for the BBC arts programme, 'Monitor'. It was shown on television the evening before an exhibition of Lloyd's work was due to open at the Portal Gallery; since there was a strike on the only other TV channel available at that time the programme had a good audience. Next morning the gallery was besieged by potential buyers and all the paintings were sold. The Portal Gallery arranged to pay Lloyd a weekly salary and he was able to give up work at the factory.

The Tate Gallery bought one of Lloyd's paintings, as did Leeds City Art Gallery, York Art Gallery, the Bowes Museum and St Thomas's College, York. In 1973 he won the International Award for the best primitive painter in Zagreb.

Lloyd exchanged paintings with L.S. Lowry who admired his work; Lowry also wrote the introduction to the catalogue for Lloyd's last one-man show in 1971.

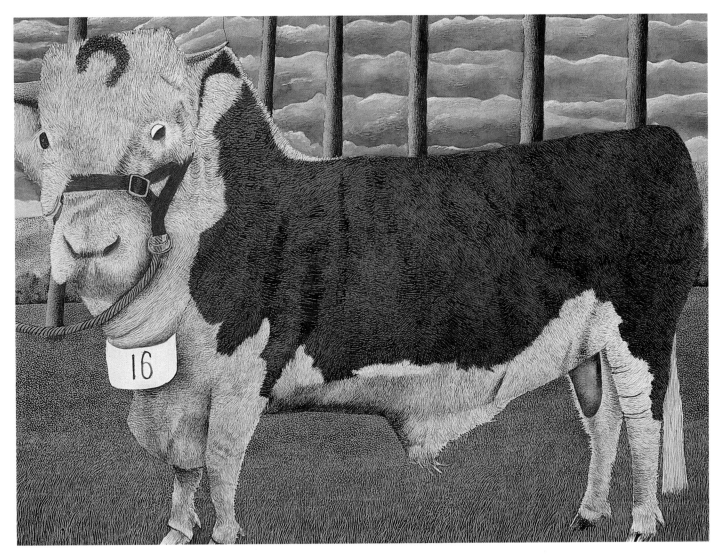

James Lloyd *Bull*

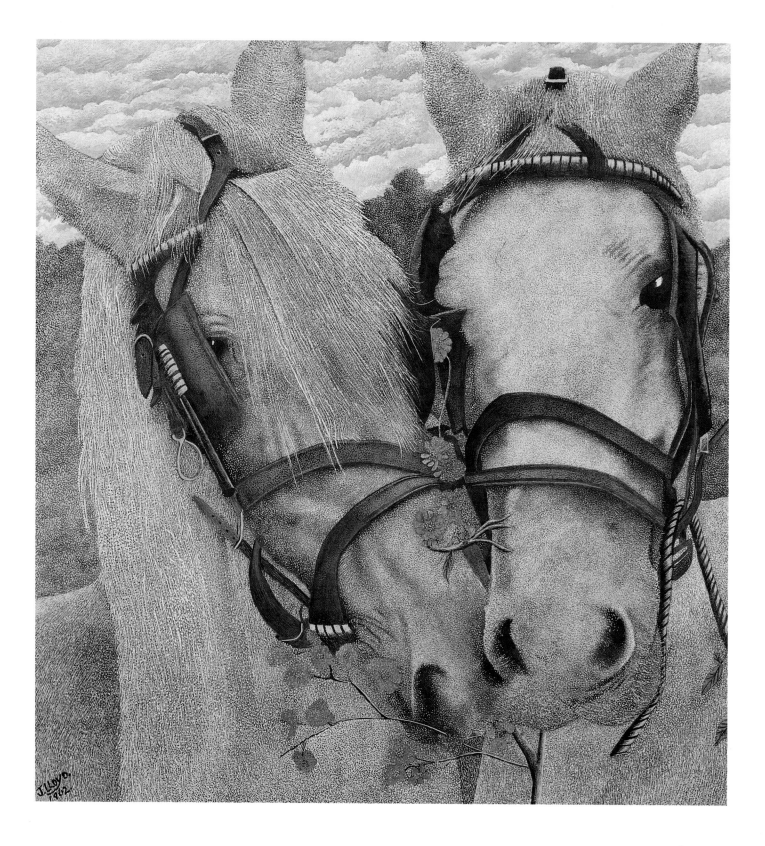

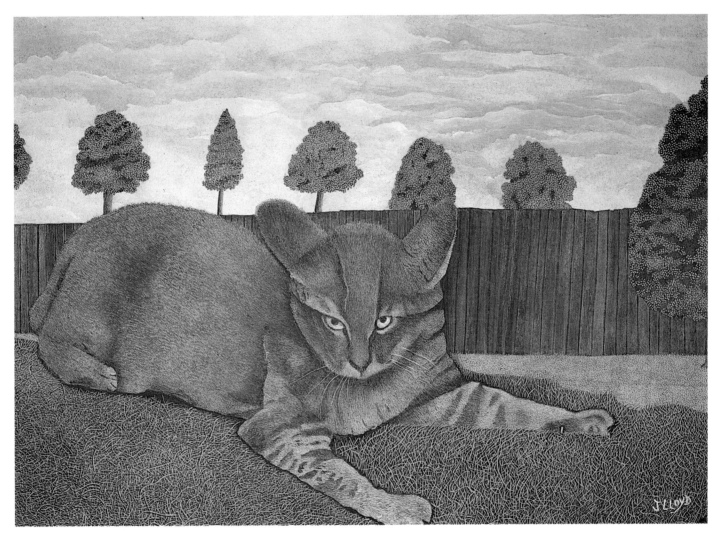

James Lloyd *Tabitha*

James Lloyd *Two Horses*

Cliff Astin

1905

Cliff Astin first became interested in painting when he called to collect his wife from her afternoon art class; persuaded to join by the others in the class, he painted his first picture. He was then sixty-seven years old.

His first painting was an impression of old Burnley town centre as it used to be in the 1920s. Since that time he has painted many scenes of old Brierfield, Burnley and Blackpool: he enjoys painting the buildings and townscapes that have now disappeared and reminiscing about the good times he used to have singing the latest hit songs in Lawrence Wright's singing booths, and the free dancing classes that were held three times a day on the Central Pier, Blackpool. At one time Cliff had his own dance band and played clarinet and saxophone.

Cliff Astin is now a member of the Blackpool Art Society which recently celebrated its hundredth exhibition. When he took one of his paintings to the Society's studio for appraisal by a visiting tutor, he was told: 'I like that picture and whoever has painted it must take no notice of anyone, and paint in his own style.' The next year when the same tutor returned to Blackpool, he was delighted to find that Cliff had followed his advice.

Cliff makes a detailed drawing before he starts to paint; when he is satisfied, he transfers the drawing to board and begins painting in oils. He likes to think carefully about any new subjects, and prefers to start while the idea is fresh in his mind.

Cliff Astin's paintings have been exhibited at the Ikon Gallery, Birmingham, and the Portal Gallery, London.

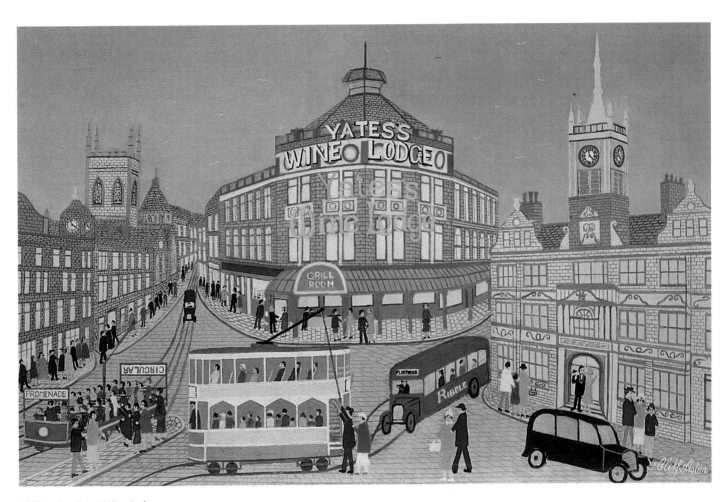

Cliff Astin *Yates' Wine Lodge*

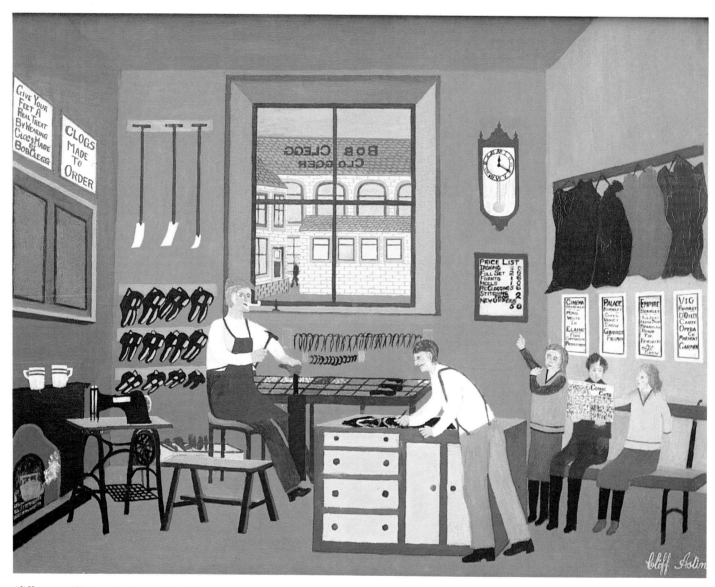

Cliff Astin *Old clogger's shop in Brierfield*

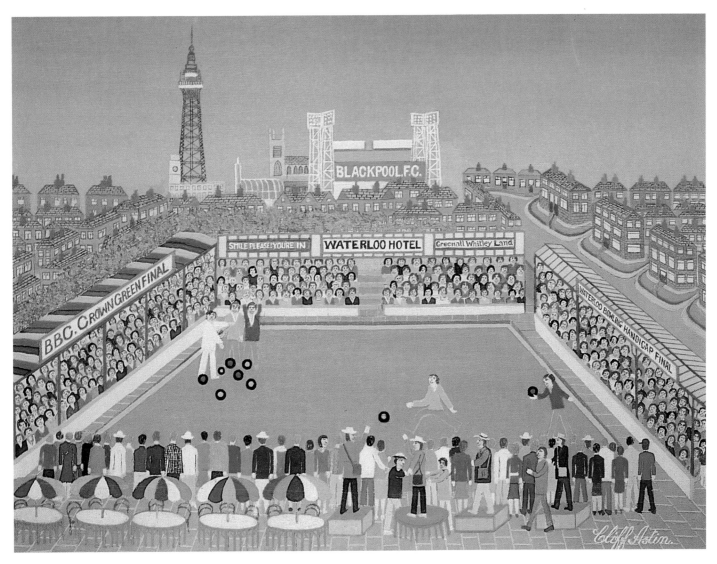

Cliff Astin *Crown Green Bowling*

John Maxwell Nithsdale

1910

John Maxwell Nithsdale's parents had a shop in Gorton, Manchester, where he was born. As a schoolboy, John had a difficult time, remaining in the same class for three years because he suffered from bronchial asthma. At the end of each autumn term, the Board of Education doctors would declare him unfit for school and his parents would then send him to stay on his Uncle Harry's farm; John would spend the spring and summer wandering on his own until the village children came home from school.

When he left school, he served his apprenticeship on locomotives at Beyer Peacocks, Manchester, and later worked as an aircraft fitter with A.V. Roe. During the Second World War he was Chief Inspector at the Burtonwood Aircraft Depot.

John started painting as a hobby during the war. The air-raid shelter was at the other end of the street, and since going out into the icy cold brought on asthma attacks, he buttressed up the space under the staircase and put in a bunk bed. To help pass the time during the raids, he made drawings of workshop scenes. Later this developed into using water colours and then oil paints. John draws in pencil on hardboard, then outlines everything in either black or white oils, carefully checking the composition as he goes.

Until he retired, John generally painted at work during his lunch hour, as his wife did not like his paintings or the smell of oil paint. Nowadays he paints at home in the morning, leaving the afternoon free for housework, shopping and taking his dog for a walk.

John Maxwell Nithsdale was introduced to L.S. Lowry by Andras Kalman. The two men became friends and visited each other's homes. Lowry opened a one-man show of John's paintings, and he became known as his protegé. In 1980, Andras Kalman commissioned John to paint L.S. Lowry's house.

There have been several exhibitions of John Maxwell Nithsdale's work in the Manchester area, and his paintings are in public collections at Salford, Leicester and Stockport, and in private collections including those of Her Majesty the Queen and the late Gracie Fields. In 1984 John was delighted when one of his paintings, *The Milk Train*, was hung at the Royal Academy Summer Exhibition.

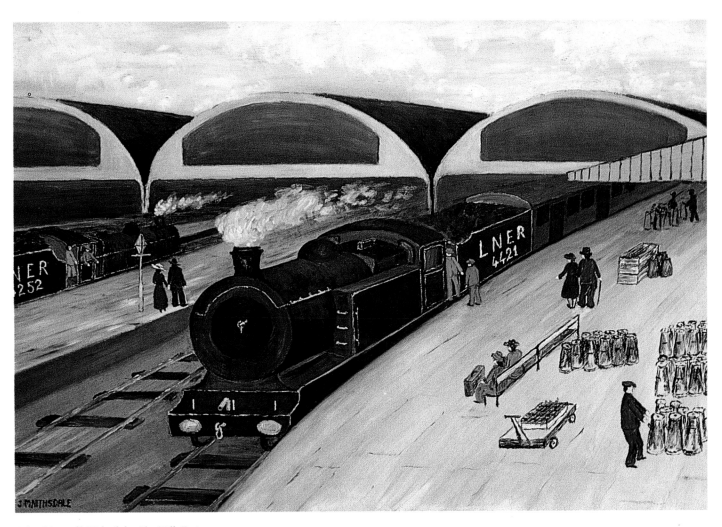

John Maxwell Nithsdale *The Milk Train*

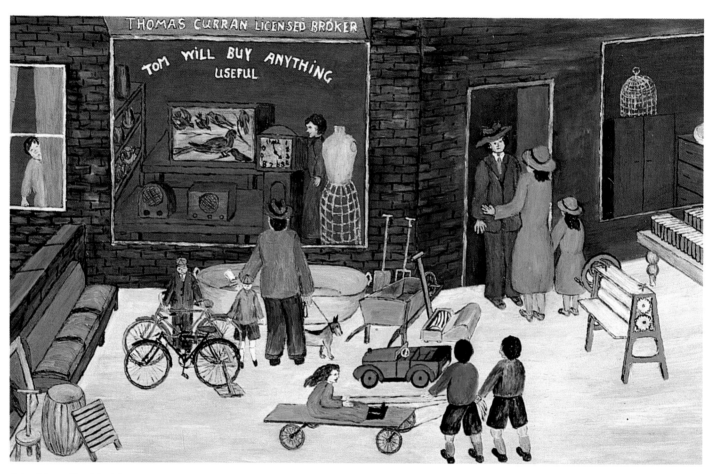

John Maxwell Nithsdale *Tom will buy anything useful*

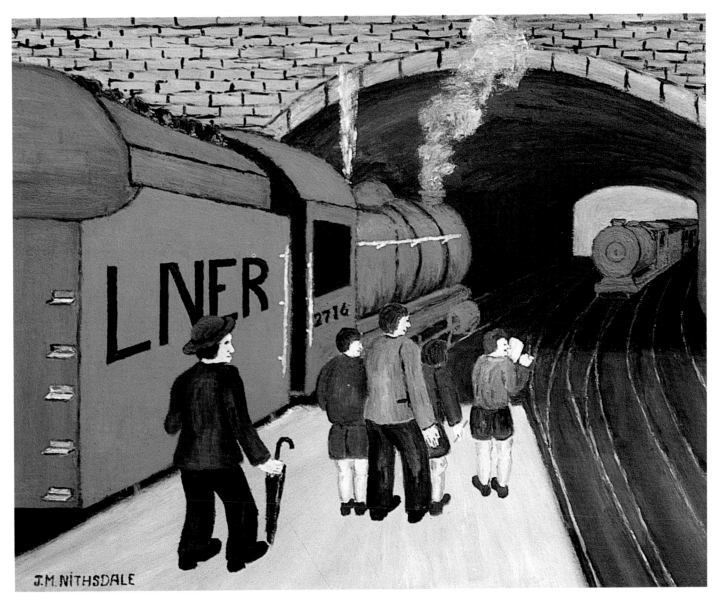

John Maxwell Nithsdale *Train Spotters*

Neil Davenport

1913–1983

Neil Davenport was educated at Marlborough, where his father was the school's Bursar. In the 1920s, when Neil was in his teens, he was fascinated by the magnificent, luxurious motor cars of the era. He and his school friends kept a close watch on the new models and once Neil wrote to a dealer saying he would like to receive further information on their latest limousine. One afternoon, Neil was called from class to meet a gentleman standing beside a gleaming Rolls-Royce. Realizing there had been a mistake, the salesman took it in good spirit and invited Neil and his friends to go for a drive.

Neil Davenport had a successful career as a London photographer in partnership with John French, but he gave it up to become an artist. He taught himself to paint in the mid-1950s, basing his compositions on experiences he had of travelling around Europe as a young man. His was a nostalgic world of Somerset Maugham, P.G. Wodehouse and Scott Fitzgerald.

Neil Davenport had several one-man shows at the Portal Gallery, and his paintings were exhibited widely in Europe.

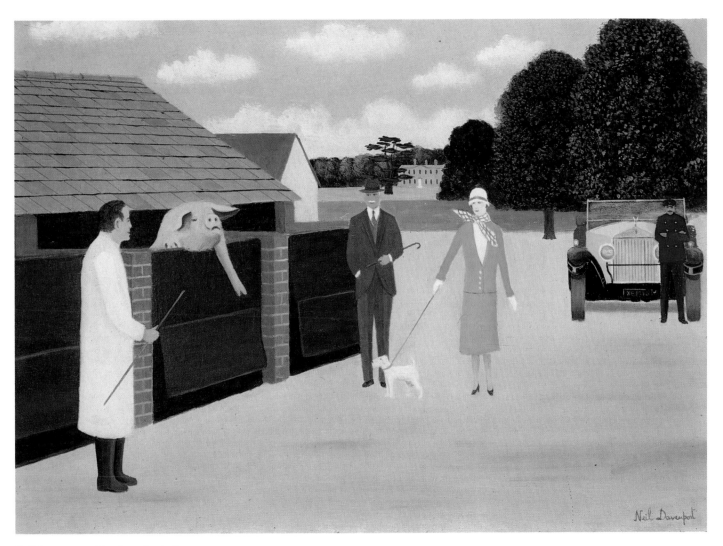

Neil Davenport *Blandings Castle Pig*

Anthony Miller

1914

Born in Stockport, to an unmarried mother, Anthony Miller lived in very poor circumstances until at the age of eight he was admitted to hospital, where he has remained all his life. He is employed in the hospital workshop, and spends most of his free time drawing on old shoe-boxes or other odd scraps of cardboard. He is reluctant to part with his pictures. Anthony can neither read nor write, and his experience of the world is limited to what he sees on television, the life in hospital, and a few outings. George Murray, who met Anthony some years ago and to whom we owe these biographical notes, says that he always looked down at his shoes, never looking up even when someone spoke to him.

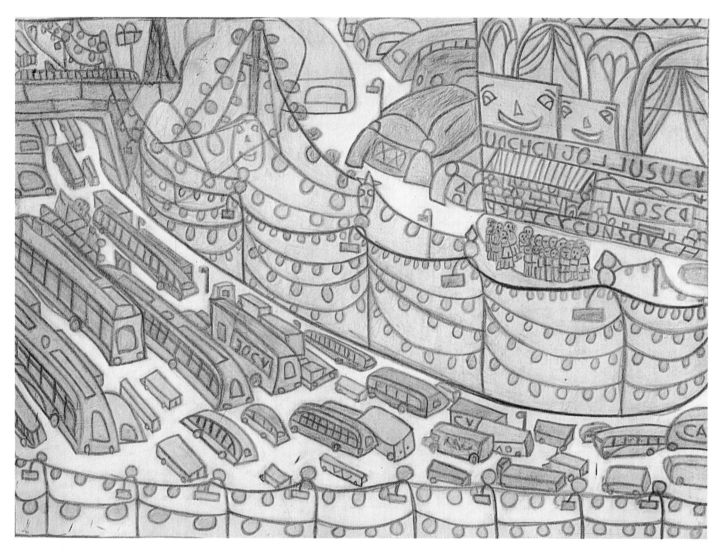

Anthony Miller *Going to the Lights*

C.T. Phipps

1916

C.T. Phipps was born in Bedwas, Wales, and learned how to make things from his father, a blacksmith at the nearby colliery. When he was fourteen, he followed his father and started work in the blacksmith's shop, a job which called for a little drawing and occasionally some creative work.

C.T. Phipps was sixty before he made his first painting. A new 'snap' room for lunch breaks was built at the colliery. To stop the miners covering the walls with graffiti, C.T. Phipps painted a picture of the local church and mountainside on one of the walls, using emulsion paints that he found in the store. Everybody liked the painting and it is still there, 'As good as when I painted it.'

In 1978 C.T. Phipps retired, and went to a local art class once a week. He painted three pictures that year, and when his daughter, an art teacher in London, saw them she entered the paintings for selection in the Royal Academy Summer Exhibition. Much to his surprise two were accepted.

Using any medium, but preferring water colour, C.T. Phipps roughly plans out the composition in pencil and then paints it in. At the moment animals are a favourite subject, but he would like to do some portraits one day. A member of Caerphilly Arts Society, he has won three firsts and one second prize in their yearly competition and has also exhibited at the Portal Gallery, London, in mixed shows.

Twenty-five years ago, C.T. Phipps built his own bungalow in Bedwas, Wales, a village surrounded by beautiful mountains and woods. He finds the dormer bedroom an ideal place to paint with its views over the countryside.

C.T. Phipps *A Welsh Baptist Chapel*

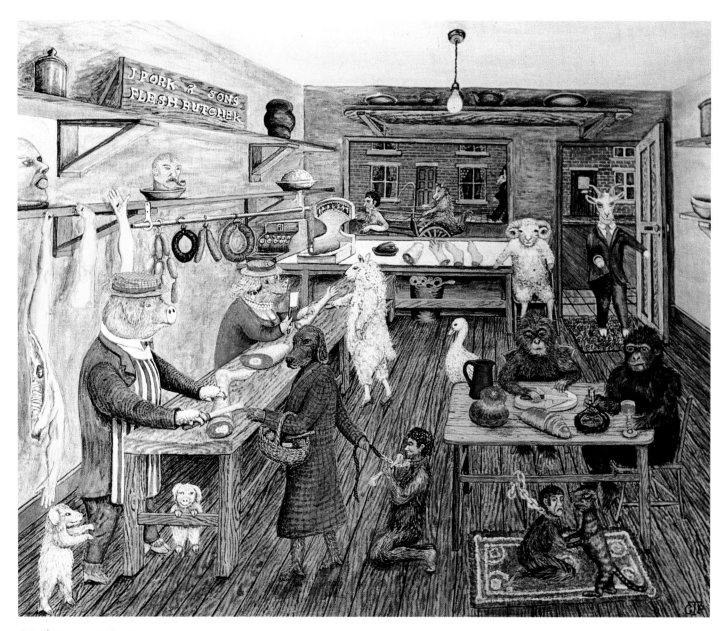

C.T. Phipps *Mr Pork's success*

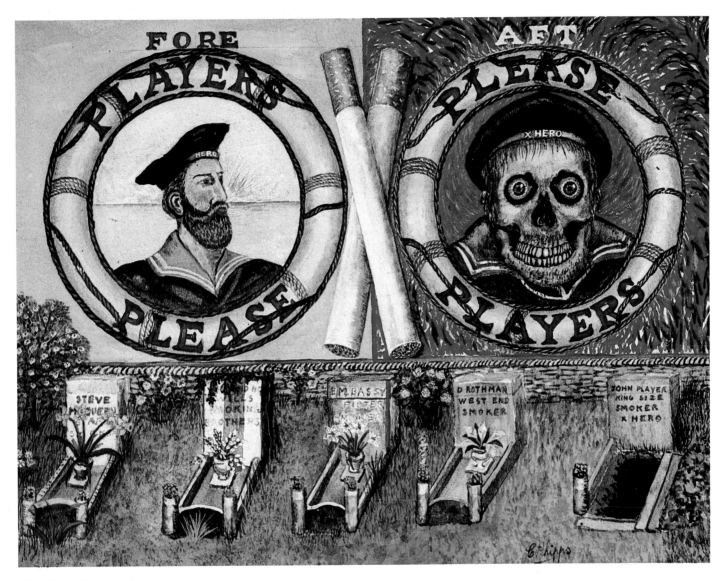

C.T. Phipps *Fore and Aft*

Francis Hill

1917

At school near Barnsley, Francis Hill was more interested in sport than academic achievement. He left at fifteen and worked in the local glass works until he was able to realize his ambition to become a constable in the West Riding police force. After the Second World War he joined Leeds City police, and was a Detective Chief Inspector when he retired in 1966. After some time as chief security officer in a bank, he was appointed Head of Security at the National Gallery and National Portrait Gallery, London.

Watching the restorers, students and copyists at work in the galleries, Francis felt that he, too, could paint. He mentioned this to his wife, and at Christmas 1974 she presented him with a very large parcel containing oil paints, brushes, canvasses, an easel, a book on oil painting and a note which said, 'Now get on with it.'

Francis wanted to record in paint some of the interesting events in his life, and began by recollecting various incidents from his years in the police force and the army as well as domestic life. He found his early police training in observation very useful when he started to paint. He usually works from a sketch, transferring this to canvas when he has achieved the correct composition. In 1975 he entered his pictures in a staff art exhibition at the National Gallery and was greatly encouraged by the enthusiastic response he received. Each year since 1976 he has had paintings accepted at the Royal Academy Summer Exhibition, although they have not always been hung.

Francis Hill retired from the National Gallery in 1982: 'I am now a compulsive painter, trying to make up for time I lost before I realized I could paint.'

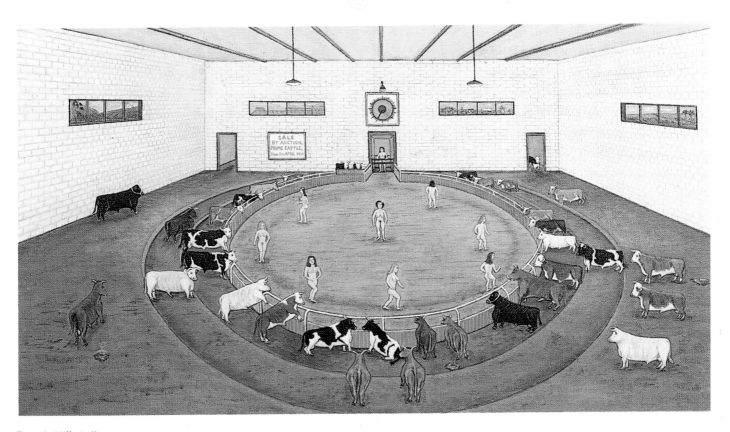

Francis Hill *Bull'seye*

Gertrude Halsband

1917–1981

Gertrude Halsband was born in Mossley, near Aston-under-Lyme, where her father had a fish-and-chip shop. Her mother, aunts and grandparents worked in the shop which became the meeting place for a wide circle of family and friends. Later, the family moved to Batley, near Leeds.

Gertrude always loved painting and as a child wanted to be an artist; but when she left school, she had to earn her living and so she designed and made dresses and millinery. She came to London and met her husband, a tailor. They lived together in a small flat in Knightsbridge behind Harrods.

In 1975 Gertrude retired from work and was able to take up painting seriously. She had an exhibition at the Portal Gallery in the late 1970s, and was later in various mixed shows organized by the Register of Naïve Artists, including an exhibition of International Naive Art at Hamilton's Gallery in London in 1979.

Gertrude was always interested in clothes and her favourite subjects for painting were scenes from her childhood, usually crowded with people neatly dressed in the style of the twenties or thirties.

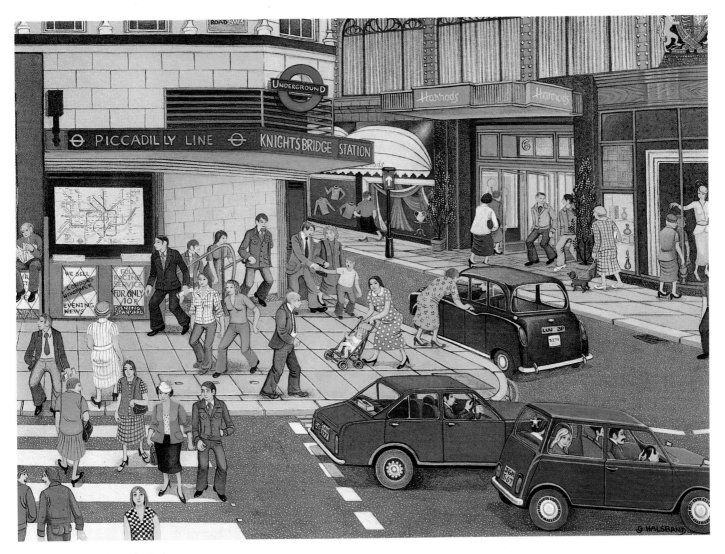

Gertrude Halsband *Knightsbridge*

Andrew Murray

1917

Born in China, where his father was a lecturer at Tientsin Anglo-Chinese College, Andrew Murray was educated in England at Eltham College and later Wadham College, Oxford.

After five years in the Royal Navy from 1940 to 1945, Andrew became a journalist working in Cape Town. Although he enjoyed art at school, sometimes winning the class prize, it was not until 1956, when he was thirty-nine, that he painted his first picture, an imaginary one of a ship in a harbour. Andrew then realized that this was what he wanted to do, and has been painting ever since. His first one-man show was held in 1962, but he continued to work as a journalist until 1969, when he became a full-time artist.

Andrew Murray used to paint many imaginary subjects: people and animals in landscapes, scenes from the Old Testament, classical subjects, flowers and always the cities in which he has lived – Paris, Seville, Perugia, Cape Town and London. He has done over a hundred paintings of London, and in 1980 a book, *Andrew Murray's London*, with a selection of these pictures was published by Blackie. Since 1976 Andrew has been publishing reproductions of his work as greetings cards, a business largely run by his wife, Beryl.

In 1978 Andrew went to printmaking classes at the Heatherly School of Fine Art in London to learn etching. He enjoyed tackling the new problems presented by this method of printing, and has now made a number of limited edition etchings.

Andrew Murray has often been commissioned to paint specific buildings by companies or collectors of naïve painting. When he has chosen the subject for a picture – for example the Albert Hall, Kings Cross Station or a less well-known corner of London – he does a small drawing on the spot. Later, at home, he does a larger version on canvas, followed by underpainting and final modification of colour and details. He paints in his flat near the Kings Road, beside a window which has a view over a wild cherry tree, with St Luke's Church, Chelsea, in the distance.

Andrew Murray has had six one-man shows at the Portal Gallery, and has exhibited his work in many group shows of naïve painting at home and abroad.

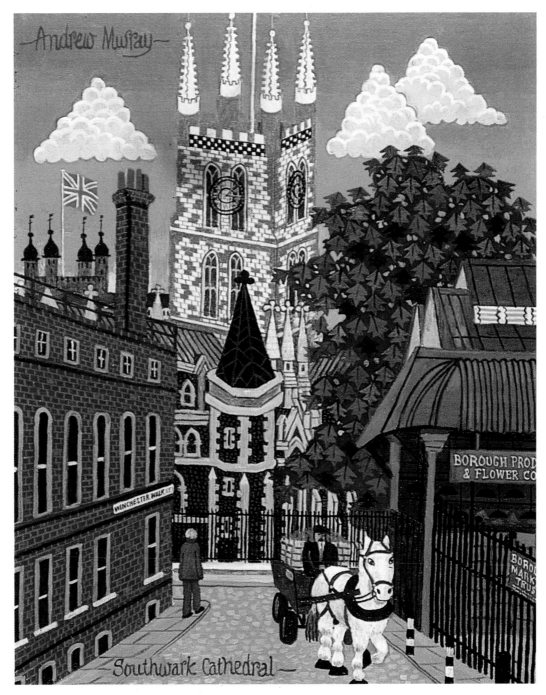

Andrew Murray *Southwark Cathedral*

Ada Currie

1920

Painting was Ada Currie's one good subject at school and she came top of the class. When she left to start work, her art teacher told Ada's mother to send her to night school as she showed talent but needed training. Ada says, 'We were very poor and my dear old Mum wasn't interested – she was just glad that I was going to work and bringing home twelve shillings (60 pence) a week.'

When Ada was forty-four her husband died and she went to work at Gallery Five, a London greetings-card publisher. She liked going into the art department to look at the work that had been sent in for reproduction and after some time thought she would like to have a try. She bought a beginner's oil paint outfit and when she had done her first painting she took it to show a friend who worked in the art department. Her friend liked the picture and encouraged her to keep painting.

Ada gave many of her pictures to people at work. One day Jan Pienkowski, the Art Director of Gallery Five, sent for Ada and asked her how long she had been painting and if she had any more work to show him. To her surprise he commissioned her to paint a set of pictures which could be reproduced as postcards 'and that's how it started'.

Ada usually paints on Sundays or in the evenings. She works in a corner of her sitting room with one eye on the television, and starts by painting directly onto canvas. She says, 'Sometimes I have a board in front of me and haven't any idea what I want to do.' Ada works on one painting at a time but might do two or three skies together. She enjoys doing country scenes with cornfields and trees, and would like one day to try her hand at portrait painting.

Ada lives in a basement flat in Paddington. She finds painting very relaxing and says, 'I don't have a favourite artist, but I do like paintings to be lifelike. I do not like abstract art.'

The Portal Gallery had a show of Ada Currie's paintings in 1979.

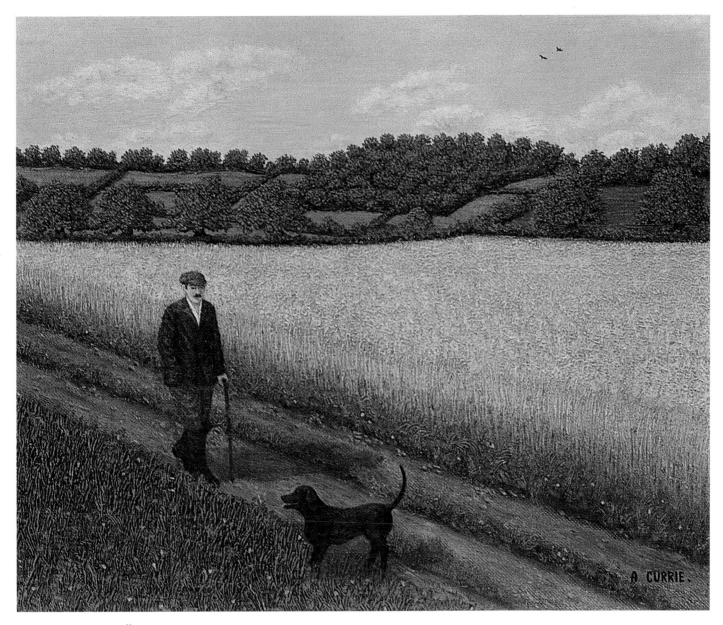

Ada Currie *Country walk*

Bernard Carter

1920

Bernard Carter's uncle encouraged him to paint, and he was also well taught at his London school where it was suggested he should go to art school. After six years in the RAF during the Second World War, he eventually became a student at Goldsmiths College of Art, London; he then became an art teacher, and in his spare time taught 'my most difficult pupil, myself, to paint'.

Until he retired, Bernard Carter was Keeper of Paintings at the National Maritime Museum in Greenwich. Now he paints nearly every day, working on four or five paintings at different stages of completion. He uses oil paints straight on to canvas, but occasionally makes a preliminary drawing on paper. He then tries 'to persuade' the whole painting to develop to the same degree of finish in all its parts. His subjects are landscapes, riverscapes, canals, owls, geese and cockerels. Bernard works in his studio at the top of his Regency house in Greenwich, where he lives with his wife who is also an artist.

Bernard Carter first exhibited at the Royal Academy while still a student, and subsequently in many mixed shows of painting. Over the last twenty-one years he has had nine one-man shows at the Portal Gallery, London.

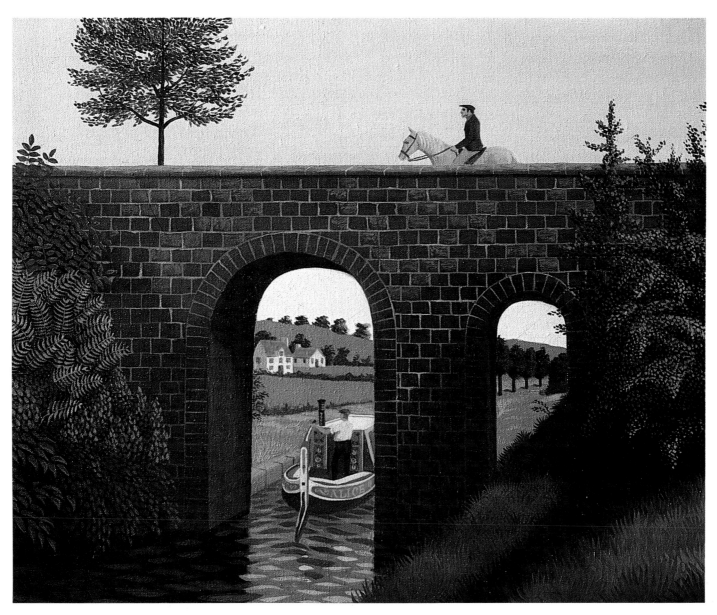

Bernard Carter *Rider on a bridge*

Arthur Goulding

Arthur Goulding went to school in Bradford, and left at the age of fourteen. He taught himself to play the piano and toured variety theatres week by week, occasionally having lessons when he could afford them.

He remembers how, at the age of ten, he painted an apple in water colour at school. His teacher was so impressed that he called in the headmaster to see the painting. But Arthur did not paint again until, in his early forties, he had a more settled existence. He was encouraged in his painting by his wife and he also met George Murray who took an interest in his work.

Arthur has a full-time job as a pianist at the Dorchester hotel in London. He paints when he can during the day, if the light is good enough. He uses oils straight onto canvas. He likes painting interior and exterior scenes from imagination and, rather than just recording a scene, tries to depict the often hidden meanings he sees in emotional situations drawn from real life.

Arthur Goulding's work has been exhibited in five summer shows at the Grand Palais, Paris; twice in the Royal Academy Summer Exhibition; the Grosvenor Gallery, London; and in galleries in Manchester, Liverpool and Lancaster. He has also exhibited in Lugano, Switzerland. Some of his work has been reproduced as greetings cards.

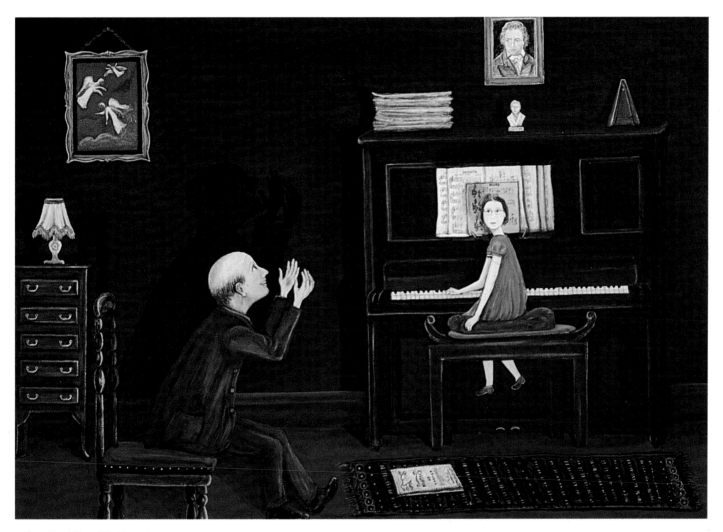

Arthur Goulding *The Piano Lesson*

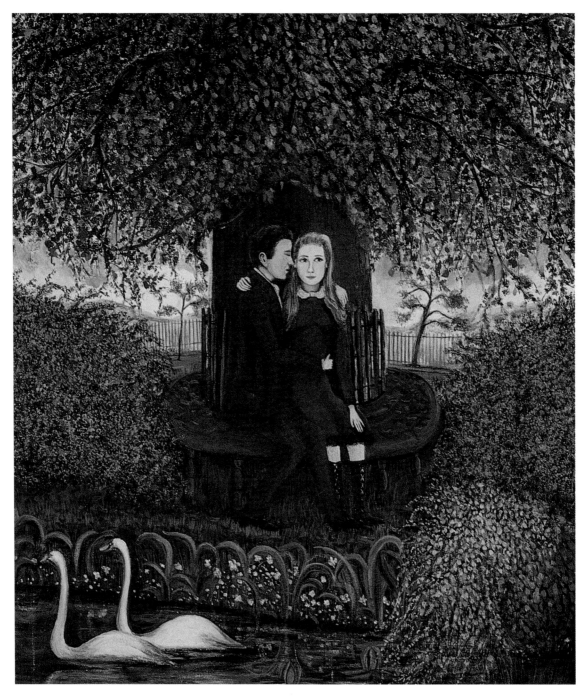

Arthur Goulding *Whispering*

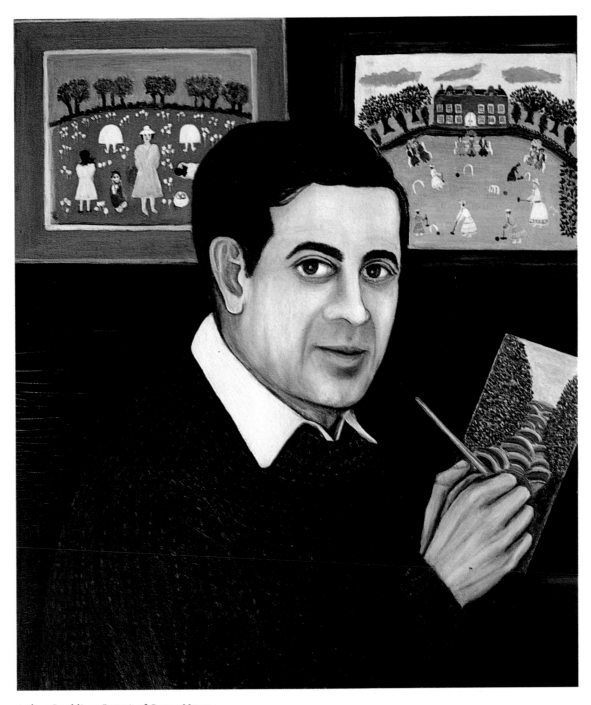

Arthur Goulding *Portrait of George Murray*

Alfred Daniels

1924

Alfred Daniels left school in Poplar just as the Second World War broke out, and took a job in a commercial art studio as a dogsbody-cum-messenger. He had not been particularly interested in art at school, but because of the shortage of skilled staff at work he was encouraged to do some lettering, layout and even illustration when needed. He showed an aptitude for the work and began to see his future in commercial art, ambitiously deciding to became an illustrator in the style of Norman Rockwell or Eric Fraser. He went to evening classes, then studied full-time at Woolwich Polytechnic with a London County Council grant of £24 a year. Alfred won a scholarship to the Royal College of Art in 1943, but had to do National Service in the RAF first. In 1947 he took up his place at the RCA and followed this with a postgraduate course in mural design.

Alfred Daniels's first paintings were done at week-ends after drawing all week at college. Because of his studio experience, he found he could finish his class work quickly, leaving him time to paint and experiment with still lives, portraits and pictures of Poplar painted from memory, since there was a war-time ban on outdoor sketching. Although these paintings were considered by others to be inferior to his academic studies, they were more meaningful to Alfred and he returned to that mode of painting many years later.

Alfred likes painting people at work and play in an urban environment and finds events such as football matches and regattas a constant source of ideas, because they stimulate a direct response. He particularly dislikes the pretentiousness of most 'fine art' themes, and prefers the common scene. A part-time lecturer in art, he has written three books on the technique of painting and drawing. He has had many exhibitions of his work, and has carried out commissions for clients as diverse as Oxford University Press and Bass Charrington. He was elected a member of the Royal Watercolour Society in 1972 and the Royal Society of British Artists in 1983.

Alfred Daniels works in a studio at home in a leafy west London suburb, near the River Thames.

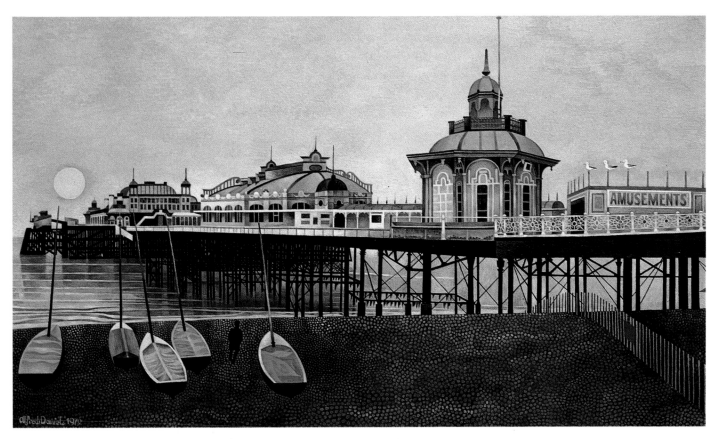

Alfred Daniels *The Derelict Brighton Pier* 1980

Jerzy Marek (George Murray)

1925

George Murray was born and educated in Poland. After the Second World War he became a chartered Civil Engineer working on the design of buildings and bridges in Preston, Lancashire. He took early retirement in 1981.

As a child, George enjoyed making and painting models he had carved himself, but was discouraged from painting pictures when his teacher told him his perspective was wrong. Many years later, in 1963, he started to paint large abstract pictures and so avoided the problems presented by perspective; but he was not very happy with abstracts and when his mother-in-law, Margaret Baird (see page 28), began to paint 'figuratively' in her own style, it inspired George to do the same.

In 1962 George and his wife began to collect primitive and naïve paintings they found in local exhibitions, They would visit the artists whose pictures they had bought, and encourage them to paint subjects close to their hearts – childhood memories or places they were fond of. Some of the many artists they helped in this way were Margaret Baird, Gladys Cooper, Arthur Goulding, William Dafter and George Pinder.

When George Murray produced his first figurative painting – two white birds in a dream-like landscape – his wife did not like it and thought his abstracts were better. Undeterred, George sent off three pictures to an international exhibition in Lugano, where they all sold and this gave him the determination to continue. His wife, still not convinced, suggested he sign his paintings with his original Polish name of Jerzy Marek.

After his wife died, George moved to Edinburgh where he now lives with Jeanette, also an artist. They each have a studio at home; George's studio is divided into two: he works in one half and in the other he keeps his collection of paintings. George Murray paints in oils straight on to board, having planned the picture carefully in his head. His subjects are varied: ships, flowers, animals and birds. When he had a full-time job, he would start painting at 7pm and continue until 11pm. Now retired, he still keeps to similar hours.

George Murray's work has been in many shows in the North; he has exhibited at the National Theatre in London and the Portal Gallery as well as abroad, and his work has been reproduced as greetings cards. Sidney Janis, the well-known American collector of naïve art, has one of George's paintings in his collection.

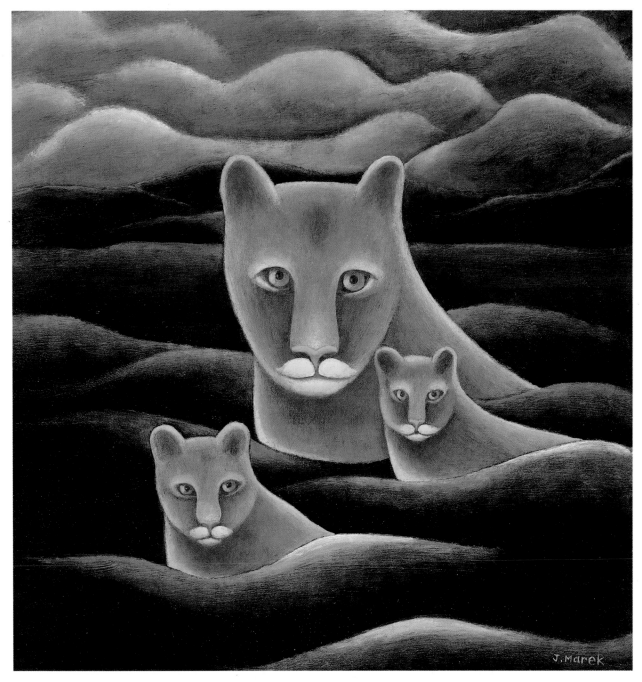

Jerzy Marek *Sea lions*

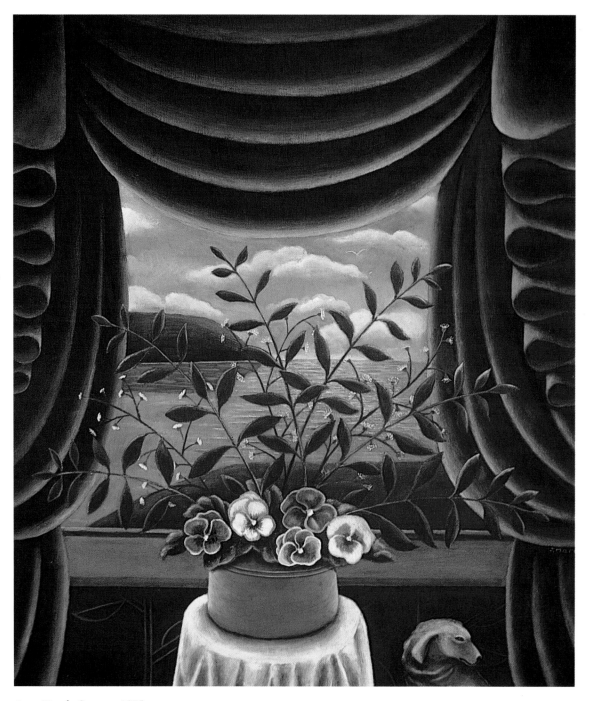

Jerzy Marek *Seascape* 1975

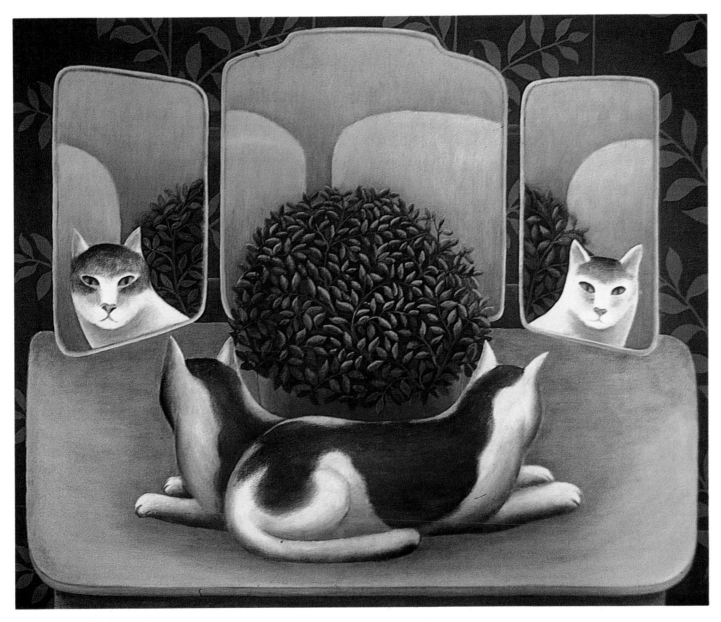

Jerzy Marek *Reflections* 1978

Beryl Cook

1926

Beryl Cook was born in Surrey. She left school at fourteen and went to work in an insurance office. After a brief stage career, followed by modelling for dress firms and running a tea-garden with her mother and sister, Beryl married John Cook, an officer in the Merchant Navy.

In the 1950s the Cooks spent some time in Southern Rhodesia, and it was here that Beryl first started to paint. She enjoyed teaching her young son to paint so much that she took over his painting set and worked on her own pictures. When the family returned to England they lived in Cornwall, and here Beryl began to paint in oil on driftwood and any odds and ends of timber she could lay her hands on. In the 1960s they moved to Plymouth, where during the summer season she ran a boarding house. As a seaside landlady she had the opportunity to observe all sorts of people, and many of her summer visitors unwittingly found their way into the paintings she did the following winter. Beryl hung her pictures all through the house, and although everyone admired them, it was not until 1975 that she let an antique-dealer friend have a few of them to show in his shop. Within a few days he had sold them, and although sad to see them go, Beryl was delighted and surprised that people wanted to buy them.

Bernard Samuels of the Plymouth Arts Centre heard about her work, and persuaded Beryl to let him put on a show of her paintings. Shows at the Whitechapel Gallery and the Portal Gallery in London and the Alexander Gallery in Bristol followed. Lionel Levy of the Portal introduced Beryl's work to the publishers John Murray, and her first book of paintings *The Works* appeared in 1978; at the same time Gallery Five produced greetings cards of her work. In 1980 her second book, *Private View*, was a best seller, followed in 1981 by *One-man Show*.

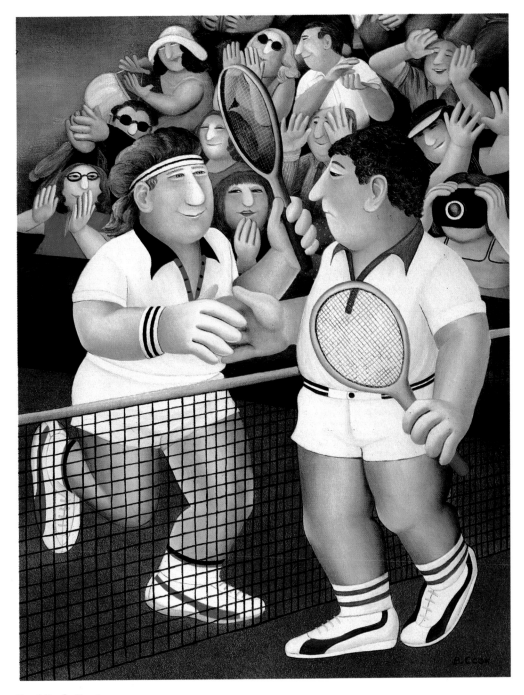

Beryl Cook *Tennis*

Bryan Pearce

1929

As a child, Bryan suffered from phenylketonuria, a rare genetic disease that causes damage to the brain. Until the age of sixteen he spent some time away from his home in St Ives at a special school, but the war years were difficult, unsettled times and his progress was slow. On his return home to Cornwall, Bryan helped out in his father's butcher's shop in the centre of St Ives.

Bryan first started painting when he was twenty-four. His mother saw that he needed a creative outlet for his energy and bought him a child's colouring book and paints. The bright colours and bold shapes intrigued Bryan enough to start colouring them in for himself, and his technique to this day has remained very similar: a meticulous filling in of pure colour within a fixed framework. This was the start of a new life for Bryan, and his parents arranged for him to attend classes at the St Ives School of painting four mornings a week, under the tuition of Leonard Fuller, who wisely allowed Bryan to develop his artistic ability at his own pace.

In 1957 Bryan had five pictures in a Penwith Society exhibition. Having his work on view alongside other St Ives artists, some of whom were well known nationally and internationally, gave both Bryan and his parents confidence in his artistic ability.

Bryan's first one-man show was held at the Newlyn Gallery in 1959, and since then he has had twenty or so one-man shows in Cornwall, Devon and London; he exhibits his work regularly at the Wills Lane Gallery and the Penwith Gallery, St Ives. His work has also been in many mixed shows at home and abroad, including the prestigious John Moores Exhibition in Liverpool in 1963 and in the 'St Ives, 1939-64' exhibition at the Tate Gallery in London in 1985.

Bryan's method of painting is slow and exacting. Working outside, he first outlines very faintly in pencil on white canvas or board the shapes of his picture – perhaps a view of the harbour or the parish church. Back in his studio, he carefully goes over the almost invisible lines again in pencil, and finally with a brush loaded with yellow ochre paint. When all this has been done to his satisfaction, he starts blocking in the colours.

Most of Bryan Pearce's paintings are detailed St Ives scenes but sometimes he paints a still life, usually flowers in a vase. Recently he has begun to use pastels and has done some small drawings of flowers and boats.

Bryan paints every day in his studio overlooking Porthmeor Beach, and his output is about twelve pictures a year. Some of his work has been beautifully reproduced as limited edition silk-screen prints, and he has also produced some etchings.

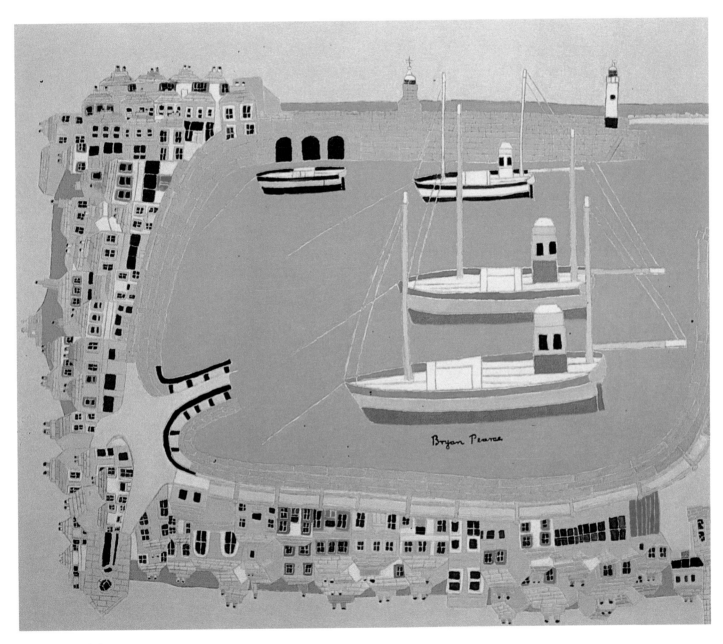

Bryan Pearce *St Ives*

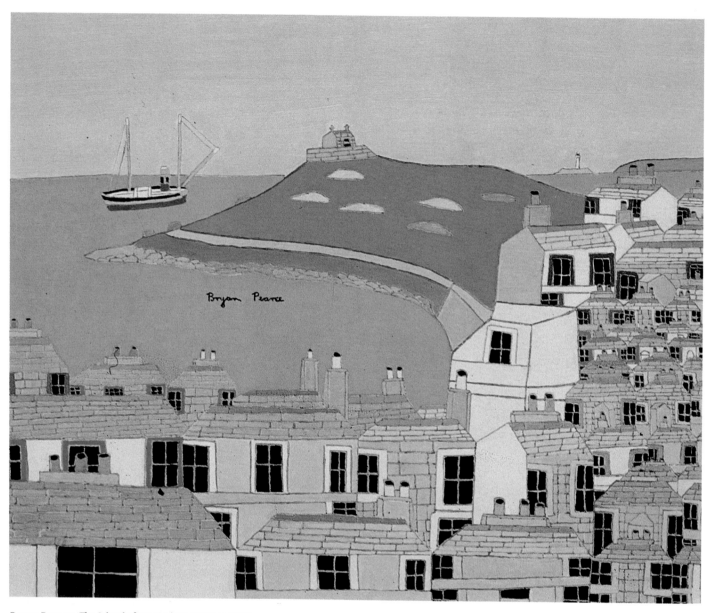

Bryan Pearce *The Islands from Godrevy Terrace* 1981

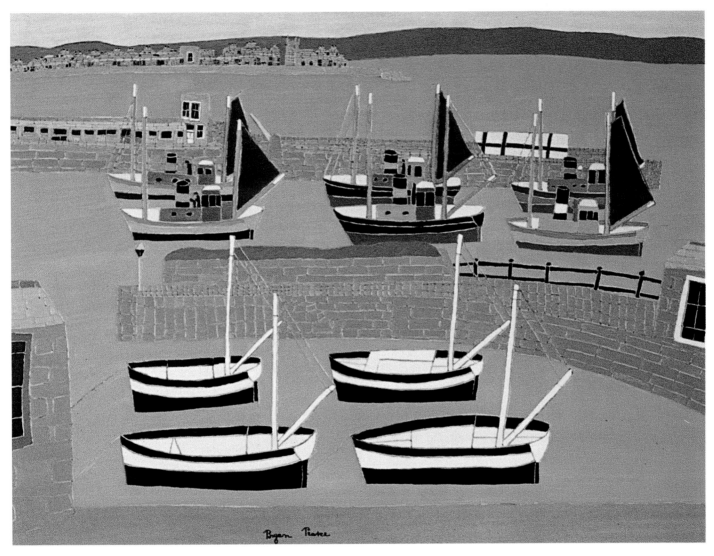

Bryan Pearce *Newlyn Harbour*

Clarice Pomfret

1930

Clarice Pomfret decided to be an artist at her infant school in Manchester, when the teacher held up a painting she had done of Little Red Riding Hood to show the class. At fifteen, Clarice was about to attend Wigan Art School, but tragically the day before term started her mother died; as her father considered educating girls a waste of time, Clarice became his house-keeper.

It was not until ten years later, with the support and encouragement of her husband, who looked after their two young children, that Clarice started going to an evening class at Bolton Art College. If anyone wanted to know where she was going, she would tell them it was her night at the pictures, as she felt an interest in art would label her a crank. In 1958 one of her paintings won first prize in the *People*'s housewives' painting competition; the prize was a holiday in Venice with the artist Mervyn Levy and his wife. This gave Clarice the encouragement she needed to keep painting, although her family came first and exhibiting her paintings was limited to the annual Bolton Art Circle show, held in Bolton Art Gallery.

Clarice uses acrylic paints as she likes their versatility and they dry quickly. She paints mostly local scenes: she makes on-the-spot sketches and composes the picture from these, painting directly on to canvas.

In 1983 two of her paintings were accepted for the Royal Academy Summer Show and this was repeated the following year.

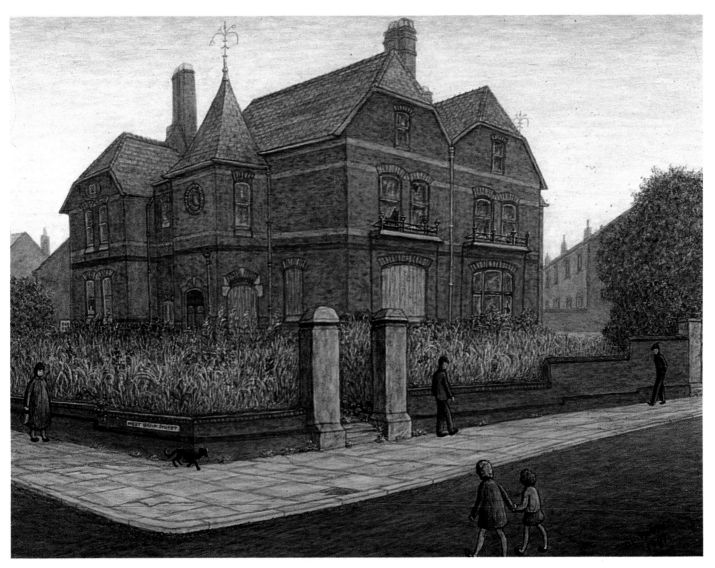

Clarice Pomfret *The Old House*

Fred Aris

1932

Drawing was Fred Aris's best subject at school and he was always being asked by the other boys to draw aircraft and guns.

Fred is a self-taught artist: he went to evening classes once or twice, but did not enjoy the experience and never went back. Until he saw a television programme about James Lloyd, he was endeavouring to paint 'like a Royal Academician'. The programme made him realize that he, too, could find his own way of creating pictures.

Fred Aris carefully plans his proposed composition on paper. When it is satisfactory, he rubs the back of the drawing all over with a soft pencil, transfers the drawing on to board and paints it in oils.

He has no particularly favourite subjects, and likes to paint anything he thinks will make an interesting picture. However, he is very fond of cats, and one of the first paintings he sold through the Portal Gallery was of a black and white cat.

Fred runs a café that originally belonged to his father. He shares a flat in Dulwich with his sister and a black cat.

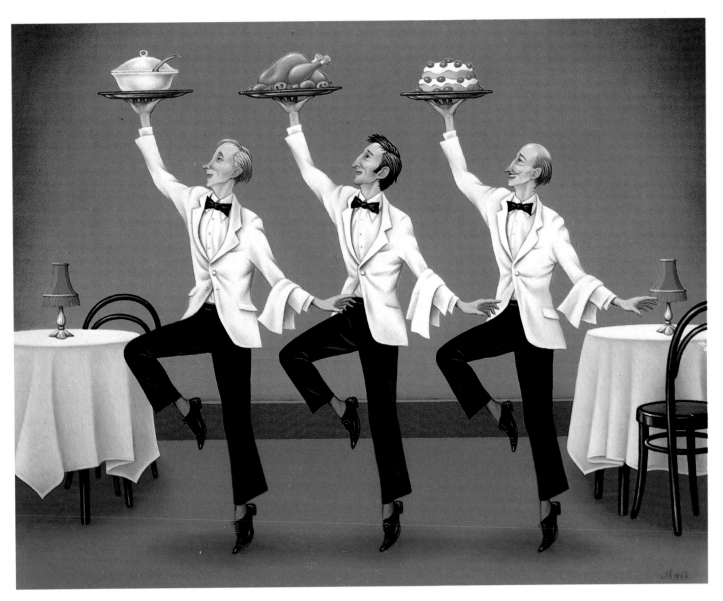

Fred Aris *Three Waiters* 1985

Bill Maynard

1933–1971

After school Bill Maynard did National Service, choosing the Medical Corps because he 'didn't want to stick bayonets into people'. A nervous breakdown ended his time in the army, and he then studied at home for entrance to New College, Oxford, to read English. Bill told Barrie Penrose in a 1966 interview for the *Arts Review*: 'There are some lovely beetles in Oxford, and I'm afraid I spent more time in the Natural History Museum than the Bodleian. After a year I got chucked out, very charmingly of course. I got married, grew a beard, became a Catholic, I forget in what order.'

He lived with his wife in Berkshire and in between assorted jobs – in offices, factories and gardens – Bill began to paint. He exhibited his work on the pavement outside the National Gallery where nice ladies would take pity on him and give him money, although at times his paintings would get kicked or scratched and even stolen. He said that his whole life, 'nearly thirty years of it, was on the wrong tack until I started painting'.

Bill liked to paint using bright colours straight from the tube – he said it seemed a pity to spoil the colours by mixing them with black. Oriental art was his greatest influence along with Egyptian, Medieval and Byzantine painting. Stanley Spencer's work first made him want to be an artist. He would sometimes work sixteen hours a day, and produced about a thousand paintings. Some were very small icon-like works, often with religious or erotic overtones. He had a one-man show, 'Billmania', at the Portal in 1966. By 1970 his paintings were selling well at home and abroad, when he suddenly became ill and died within a few weeks.

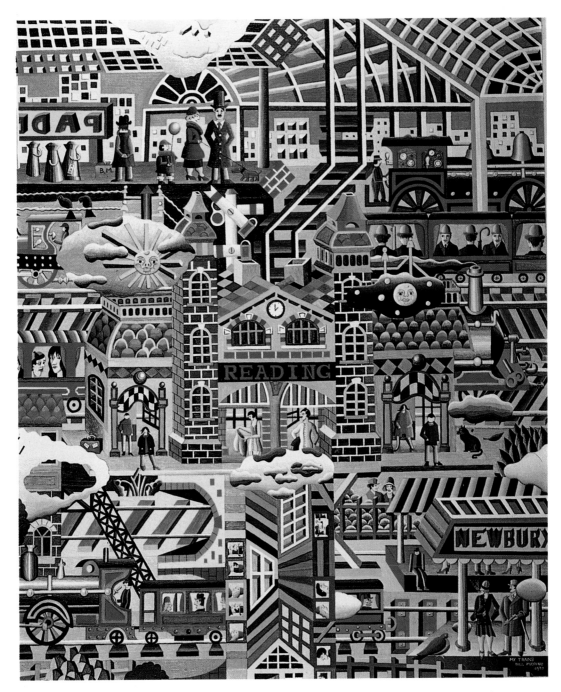

Bill Maynard *My Trains* 1970

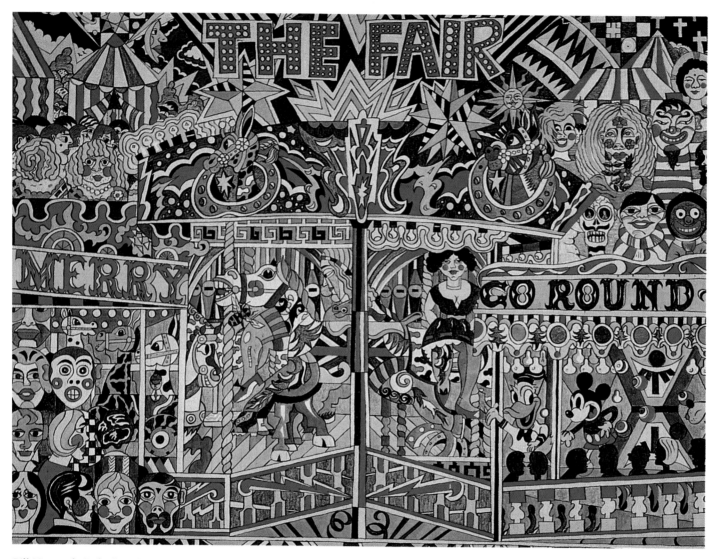

Bill Maynard *At the Fair* 1967

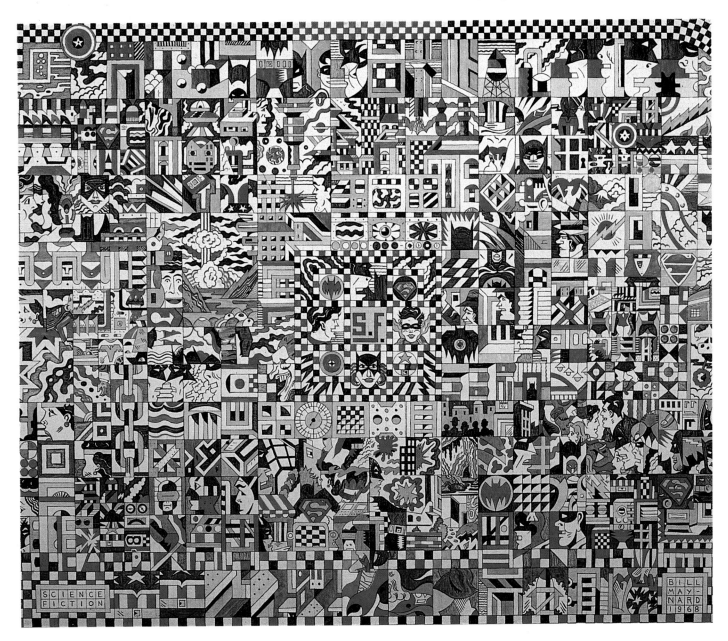

Bill Maynard *Science Fiction* 1968

William Towers

1934

William Towers was born in Preston, Lancashire. When he left school at the age of fifteen he became a grocery assistant. After National Service in the army, he worked as a shoe salesman until 1972 when he moved to Leicester and got a job in a boot and shoe factory.

One day he decided to make a collage of Adam and Eve, using scrap material that his mother had accumulated during her working life in a cotton mill. Cutting the pieces into squares, he dyed them in batches, diluting the dye to make different shades of colour.

Later, through George Murray, William Towers met an American who sold his pictures in Los Angeles. Although he was sad to see them go, with his many memories sewn into them, he was pleased that the Americans liked them.

Since 1979, he has made his living as an artist, and now spends much of his time on the Atlantic coast of Morocco where he has a studio which he has converted himself. William Towers has shown his work at the Portal Gallery for ten years and has had several one-man exhibitions. He has also had shows in New York, in the Netherlands and at the Commonwealth Institute, London.

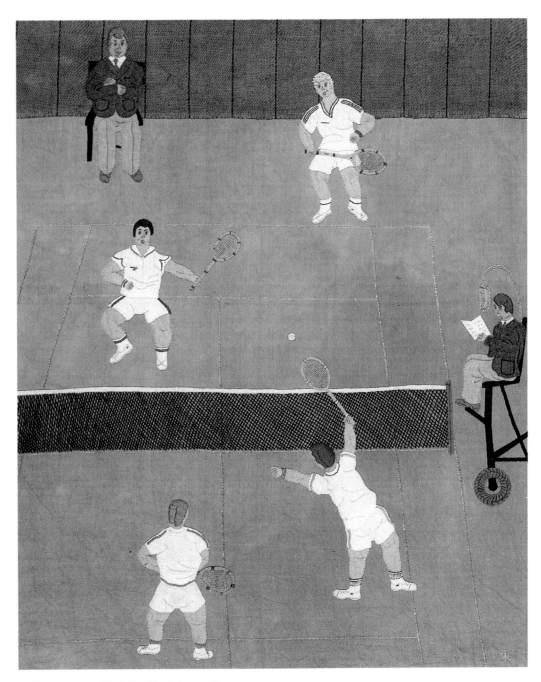

William Towers *Men's Doubles* fabric collage

John Allin

1934

One of John Allin's earliest memories is of being evacuated during the Second World War. He was one of thousands of East End children who left London by train from Liverpool Street Station, bound for Ely and the Fen country.

After leaving school and trying several different jobs, John joined the Merchant Navy. This was followed by National Service in North Africa, then at home again he was a gardener, park attendant and finally a long-distance lorry driver.

John became interested in painting while in an open prison for six months for a minor offence. At a weekly art class he learnt the basics of oil painting, and on his release began to paint the old streets, shops and markets of Hackney and the East End of London. He says, 'Being a man of the city, I paint what I know best and that is working-class life in and around where I live.'

John Allin's first exhibition of paintings was at the Portal Gallery in 1969; ten years later he was awarded the Prix Suisse de Peinture Naïve, the first British painter to win this international event.

In 1974, a book of John's paintings of the East End called *Say Goodbye, you may never see them again*, with words by Arnold Wesker, was published by Jonathan Cape, and was very well received by both critics and public. As a complete contrast, John spent the next three years travelling with Gerry Cottle's Circus where he learnt to be a clown, a tight-rope walker and generally took his share of all the many jobs necessary to keep the show on the road. He painted twenty-two pictures while he was with the circus and these appeared in 1982 as a book called *Circus Life* published by Pelham Books. His latest project has been a series of paintings showing hop picking, a traditional annual event in the Cockney calendar.

Using oil paint, John draws straight on to canvas with a brush, building up the picture he has in mind as he goes along. A full-time artist, he works at home in Hackney, in a room overlooking the garden.

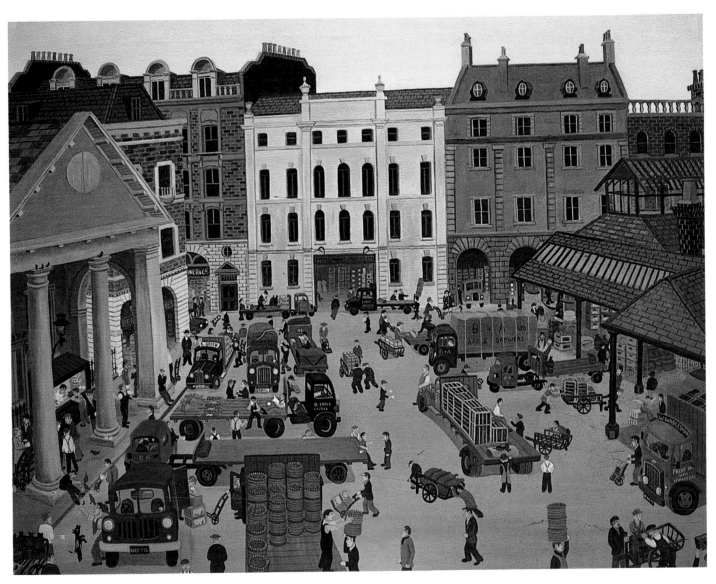

John Allin *Last days of Covent Garden* 1982

Martin Leman

1934

During the Second World War, Martin Leman was evacuated from London and spent his early schooldays in South Wales. Subsequently he went to several boarding schools, none of which he liked. Martin always wanted to be an artist: the only lesson he looked forward to was art.

After leaving school, Martin spent two years on National Service with the army in Egypt. In 1958 he studied typographic design at the Central School of Arts and Crafts in London, but left after a year. He then had various jobs in advertising until in 1961 he became a part-time lecturer in graphic design at Hornsey College of Art. He remained on the staff there until 1979.

Martin began to paint pictures in 1968. Although he was disappointed with his first efforts, he persevered; and in 1970 he sold a painting for £15 which encouraged him to continue. His early pictures were of imaginary flowers painted in glowing colours. He also did some small 'pin-ups' inspired by photographs of film stars.

During the early seventies he had two one-man shows at the Portal Gallery and his paintings were exhibited in Yugoslavia, Switzerland and France. Several of his paintings were selected for 'Body and Soul', an Arts Council exhibition, in 1976, and were shown at the Walker Art Gallery, Liverpool.

A turning point in Martin Leman's career was a painting of a small tabby cat sitting in a decorative interior: it sold immediately and so he painted another cat, this time a white one. The painting of the white cat also sold quickly: and so began his exploration of the endless possibilities and variations presented by cats. His work became widely known when a greetings-card company reproduced his paintings: the cards were available throughout the world and proved extremely popular.

In 1979 Victor Gollancz published a book of his paintings, *Comic and Curious Cats*, which was so successful that Martin decided to give up teaching and become a full-time artist. He has subsequently produced paintings for six further books, most recently *The Perfect Cat* and *Lovely Ladies*, both published by Pelham Books.

Martin and his wife, Jill, live in Islington, London. Since 1982 they have spent the summer months in St Ives, Cornwall, where Martin exhibits work at the Wills Lane Gallery. The strong light of the West Penwith area has had a marked effect on his paintings: from the dark rich interiors of the 1970s his subjects have moved out into the fresh air and sunshine of the 1980s.

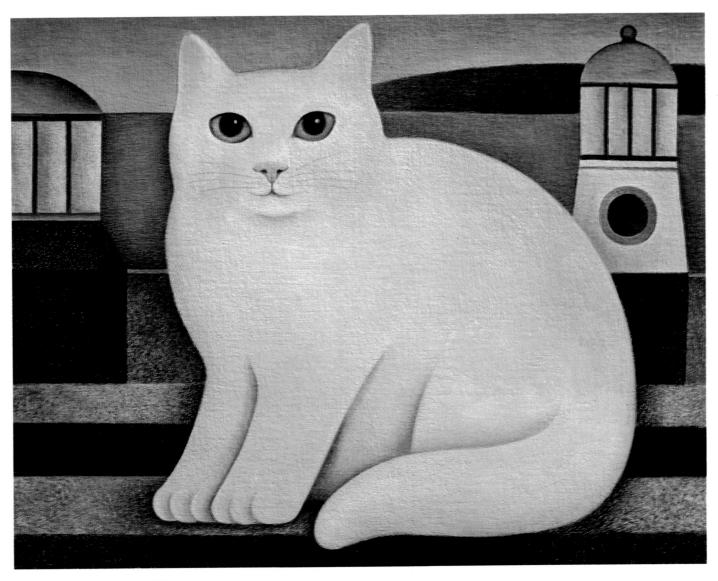

Martin Leman *On the quay* 1983

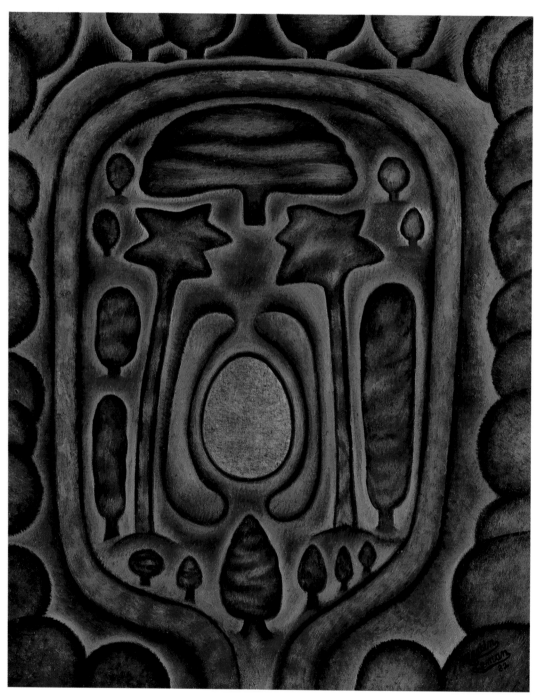

Martin Leman *The Secret Garden* 1982

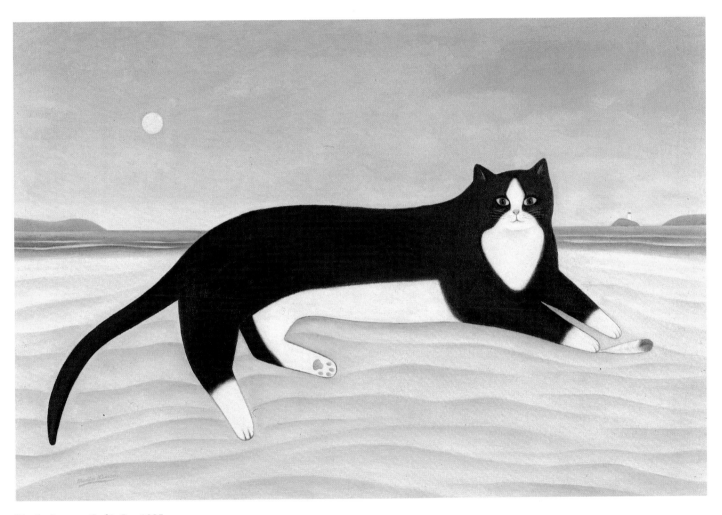

Martin Leman *Carbis Bay* 1985

Vincent Haddelsey

1934

An only child, Vincent Haddelsey was born in Lincolnshire and educated at Ampleforth, Yorkshire. He has painted and drawn since he was four years old. His first oil painting was produced at the age of eight with the help of his maternal grandmother. The painting was on a small piece of plywood and depicted a tree in leaf, a hedge and a gate. Both his grandmothers were gifted artists and they allowed him to use their paints and brushes.

As a young man, he had a variety of jobs, many of them in Canada as a construction worker. He is now a full-time artist and printmaker.

Vincent Haddelsey paints because he has a 'visual curiosity' that compels him to record his experiences. As a child he kept a visual record of anything that appealed to him – comics, the Second World War, animals, chorus girls, and ships. He travels a great deal and finds a sketch book the best way of communicating with the people he meets, especially if they do not speak English.

His paintings generally include horses: Haddelsey has always been involved with many activities concerning horses and their history. In 1978 a book of his paintings, *Haddelsey's Horses* (Cape), was published. He also enjoys painting boats, ships and locomotives, for though they are inanimate they seem to have a life of their own.

Victor Haddelsey's paintings are in museums and collections in Great Britain and Europe including the collections of H.M. Queen Elizabeth II and of the Prince of Wales. He has had one-man shows in London, Paris and New York and taken part in many mixed exhibitions.

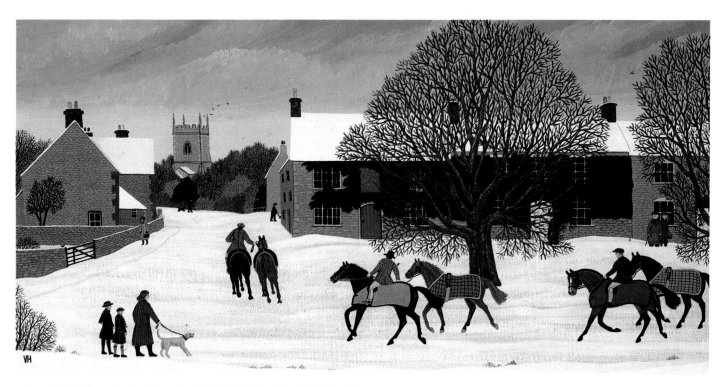

Vincent Haddelsey *Leading from the off side, Nettleham, Lincolnshire* 1982

Mabel Pakenham-Walsh

1937

Mabel Pakenham-Walsh describes herself as being a fat, restless, greedy and boring child until she discovered how to draw and make things. She tried to persuade her brothers to act in plays she had made up, and when they refused, she carved puppets from firewood with a kitchen knife and did the play on her own. In the school holidays, the entire family, led by Mabel's parents on a tandem, would set off on bicycles from their home near Lancaster to explore cathedrals, museums, art galleries and graveyards. The painted wood figures she saw in Chester Cathedral seemed like characters from a comic to Mabel, and the coloured stone tombs at York Minster as entertaining as a Punch and Judy show. When she first saw wood carvers at work, she told her parents that was what she wanted to do.

After leaving school, Mabel went to Lancaster Art School and learned carving. In the late 1950s she came to London, and by chance saw an advertisement in the *Daily Telegraph* for woodcarvers and sculptors to work at Pinewood Studios on the set of *Cleopatra*. She immediately applied for the job and was accepted. When the work on *Cleopatra* was finished, Mabel gave up carving for a time, and began to paint. A car accident in 1957 caused her to wander artistically and geographically, and she lived in Broadstairs and then Stourbridge. Mabel has now settled in Wales, sharing a remote cottage 1000ft up a mountain with Peter, an ex-schoolteacher. The cottage is surrounded by beautiful scenery, and in the garden both Mabel and Peter are encouraging wild plants, animals and insects by outlawing any use of chemicals.

Mabel starts her work at home and finishes it twelve miles away in Aberystwyth, where she has a room in the Barn Community Centre. She never makes sketches, since the carving changes radically as she works on it.

Since 1965, Mabel has had work accepted on five occasions for the Royal Academy Summer Exhibition. In the autumn of 1984, Aberystwyth Arts Centre organized a show of one hundred pieces of her work; this touring exhibition will be shown in different towns in England and Wales over the next few years.

Continuously experimenting with her work, Mabel hopes that people will be entertained and cheered by it. In the future she would like to work in stone, on larger pieces and use more colour, achieving a 'complicated simplicity'.

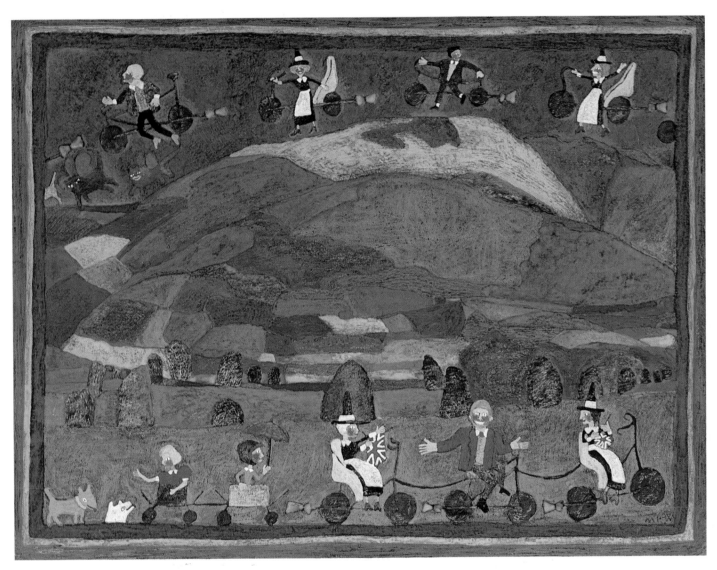

Mabel Pakenham-Walsh *Druids and witches take a trip around Saddleback and Castlerigg Stone Circle* 1971

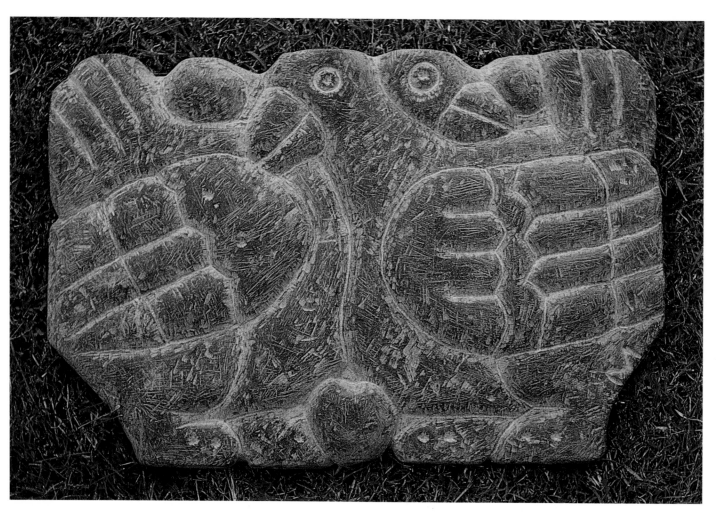

Mabel Pakenham-Walsh *Two Birds* slate carving

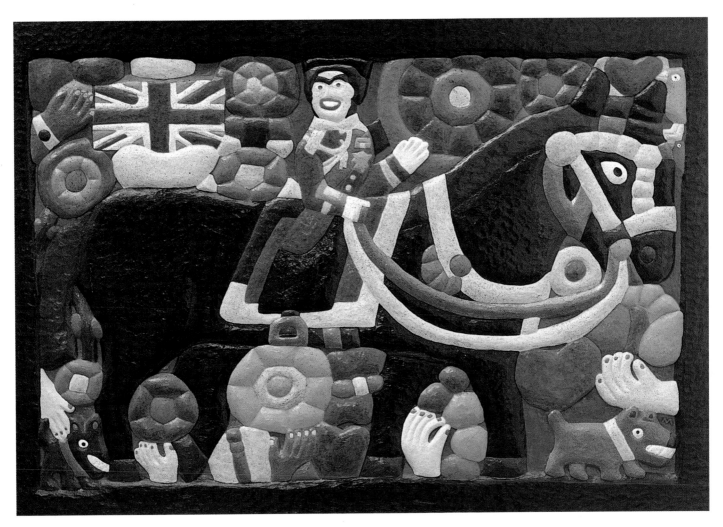

Mabel Pakenham-Walsh *The Queen* 1981

Joe Scarborough

1939

Joe Scarborough began to paint as a hobby, after he had finished his day's work as a miner. He started by copying a painting of clipperships by Montague Dawson, but his first 'real' picture was a still life of his pit boots and some daffodil bulbs.

His family's initial reaction to this painting was mild amusement: with a feeling that he would get it out of his system before long.

Joe paints regularly every day, from 8.15am until 4.30pm, with a twenty-minute break for lunch. He enjoys painting the social activity going on in the street, and loves watching people just going about their daily business. In his work he also likes to take a nostalgic look back to the 1950s, with the streets, small corner shops, steam engines, and rock-and-roll that he grew up with.

He now lives and works in a house on high ground overlooking the city of Sheffield. His view encompasses the last of the great steel works and also contains many memories for Joe – his 'tribal ground'.

Joe Scarborough uses oils, and paints straight on to canvas, having thought for a long time about the story or incident that has sparked off his interest. He sees himself as a story teller and entertainer, using canvas and paint as a stage where his figures act out a tale.

Joe has had many exhibitions in and around Sheffield and London, and hopes for the future to continue as a permanent feature of Yorkshire art. He counts as one of his major achievements having proved to his family that painting pictures is a proper job!

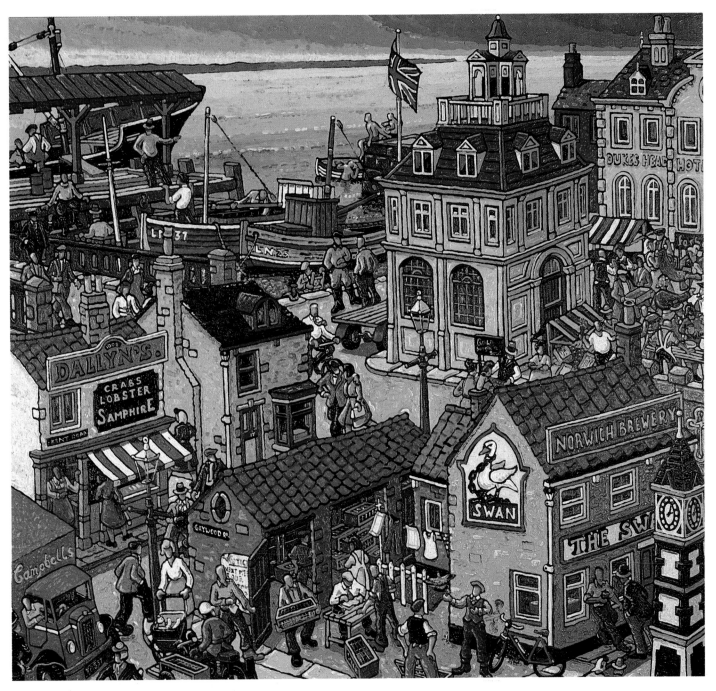

Joe Scarborough *Len Rush – Keeper of the Queen's pigeons at King's Lynn*

Peter Heard

1939

Peter Heard is a Londoner and is now a chartered civil engineer working for the Borough of Enfield.

In 1969, Peter and his family moved to Epping where one of their neighbours was Mike Dempsey (see page 124). Mike had started to paint in his spare time, and inspired by his example Peter set to work and produced his first picture, which he still has. It was of a woman baking cakes, and Peter says, 'It's terrible, but has tiny areas in it which I wouldn't do any differently today.'

Peter uses acrylic paints which dry quickly and paints at the table in the living room so that his work is always accessible and he can spend an hour or two on a picture when he gets time. He likes family activity around him while he works.

Peter's preparation for painting is an elaborate process. Having roughly sketched out an idea on paper, he takes blockboard or ply, sands it down and draws on it the outline of the painting in pencil. He then puts on a coat of white acrylic primer, and sands it down. With the pencil drawing still showing through, he re-draws in more detail over the primer and the original pencil line, then applies another coat of primer and sands it down again. This produces a very smooth surface with the outline of the painting locked in under the primer. It takes about fifty hours of painting to work the picture up to the sort of finish that Peters finds satisfactory. The completed picture is finally sprayed with polyurethane varnish and flatted off with a soft brush to give a semi-gloss finish.

Peter Heard's subjects are typically English and evocative of the recent past. His last two exhibitions at the Portal Gallery have been titled, *England's Green and Pleasant Land* and *The English at their Sports and Pastimes*. Some of the *Sports* series were published as prints, and as a calendar for 1982.

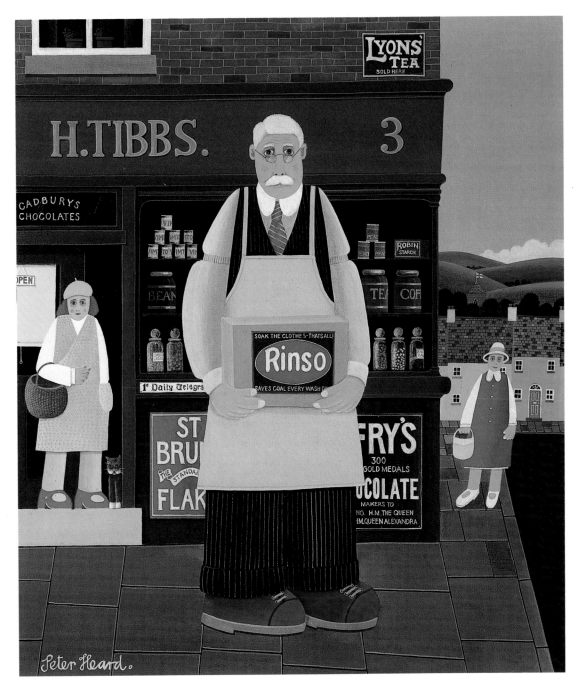

Peter Heard *Corner Shop*

Cleveland Brown

1943

Cleveland Brown was born in Jamaica, where he was strictly brought up by his parents who belonged to a particularly pious religious sect. A carpenter by trade, he came to England in 1961.

Cleveland began painting in 1974: during a tea break on a building site, he and a friend were looking through some old magazines they had found; they both decided that the photographs in the magazines were not very good and they could make better pictures themselves with paint. Cleveland went home to try, but was disappointed with the result. However, he did not give up, and on a visit to the Post Office Tower bought a postcard from which he made his own painting.

At first, the only person to take an interest in Cleveland's work was Maggie Tolliday, the Arts Officer for Brent; she tried unsuccessfully to get Cleveland's pictures shown in local exhibitions. Then in 1977 Stanley Harries of RONA (the Register of Naïve Artists) visited every borough in London looking for artists to include in a Silver Jubilee art exhibition; he met Maggie Tolliday who introduced him to the work of Cleveland Brown.

Cleveland paints three pictures a year, not having much spare time as he has a full-time job. His paintings are often large scenes packed with figures and action. He frequently introduces the royal family into his work.

Cleveland exhibits with the Register of Naïve Artists, and his work has been shown in exhibitions in Greece, Japan and America as well as London. His painting *St James's Park* is in the Arts Council Collection.

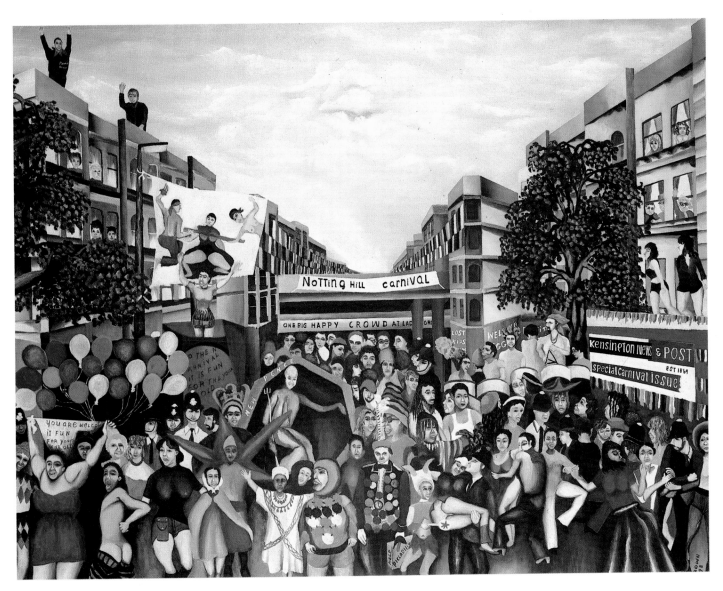

Cleveland Brown *Notting Hill Carnival* 1978

Michael Tripp

1944

Michael Tripp was born in Gwent. An only child, he attended the local primary school and then Abersychan Grammar School. He has always wanted to paint, but only recently has started again after a break of almost twenty years.

Michael can remember painting his first picture – of a farmyard – when he was six. In 1957 his painting of the railway cutting at Garndiffaith, complete with train, won first prize in a competition for local schools. A few years later in 1962, he was awarded a bronze medal at the British Railways Festival of Arts and Crafts, Swindon, for his painting *Six Bells, Garndiffaith*.

A former railway man and colliery worker, Michael Tripp started to paint after a long illness. He loves the countryside and railways and tries to recreate the past in his paintings. He works in the living room of his home, a terraced house in Pontypool, on the fringe of a mining area. Using acrylic paints, he usually draws straight onto the canvas, but sometimes makes a sketch on an old piece of card or scrap of paper first. He admires the work of L.S. Lowry and Terence Cuneo and the railway paintings of Don Breckon.

Michael Tripp first exhibited at the City of London Festival in 1981, and has since been in several mixed shows arranged by RONA.

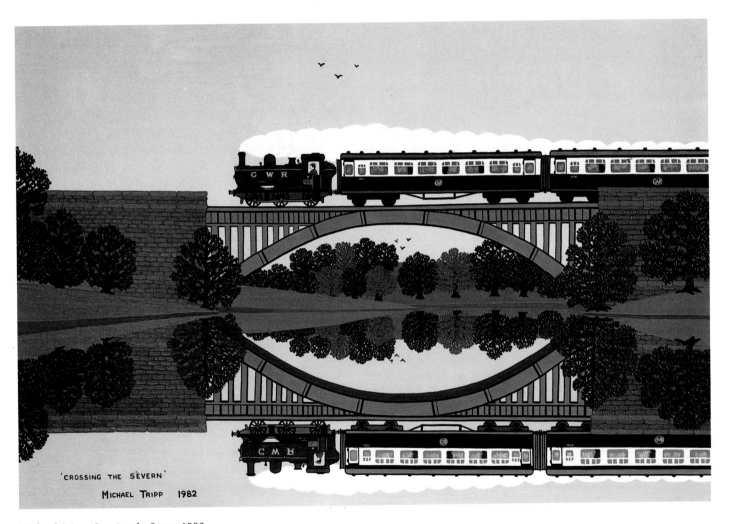

Michael Tripp *Crossing the Severn* 1982

Mike Dempsey

1944

Mike Dempsey has always made drawings but has never had any formal training. At an early age he became fascinated by Walt Disney's cartoon films.

Circumstances prevented him from going to art school, and he was forced to take a succession of uninspiring jobs ranging from shirt factory worker to stockbroker's clerk. Unhappy and frustrated, he attended evening classes to study calligraphy; in the college library he discovered graphic design and devoured every book on the subject that he could lay his hands on. He finally managed to join a studio as a messenger whilst still studying in the evenings. He moved from studio to studio, learning more at every stop. Fourteen jobs and twenty years later, his career having included the art directorship of two leading London publishing houses, he formed the design consultancy Carroll & Dempsey Limited. Mike has won two silver awards for his work given by the Design and Art Directors Club of London.

Mike Dempsey started painting seriously in 1968, initially for book jacket commissions; later he experimented with images from his childhood, landscapes and architecture. Using a simple notebook he jots down ideas; later transfers them to blockboard and paints in acrylic. To date Mike has painted about fifty pictures. Pressure from his design practice has prevented him from painting as much as he would like, although he is at present working on some large-scale paintings on the subject of industrial architecture that have been haunting him for some time. He has never had a one-man exhibition, but his paintings have been shown at the Portal Gallery, RONA, European Illustration, Cooper Hewitt Museum, New York, and an American travelling exhibition organized by the Smithsonian Institution.

Mike Dempsey lives in Old Harlow, Essex, with his wife, daughter and twin sons.

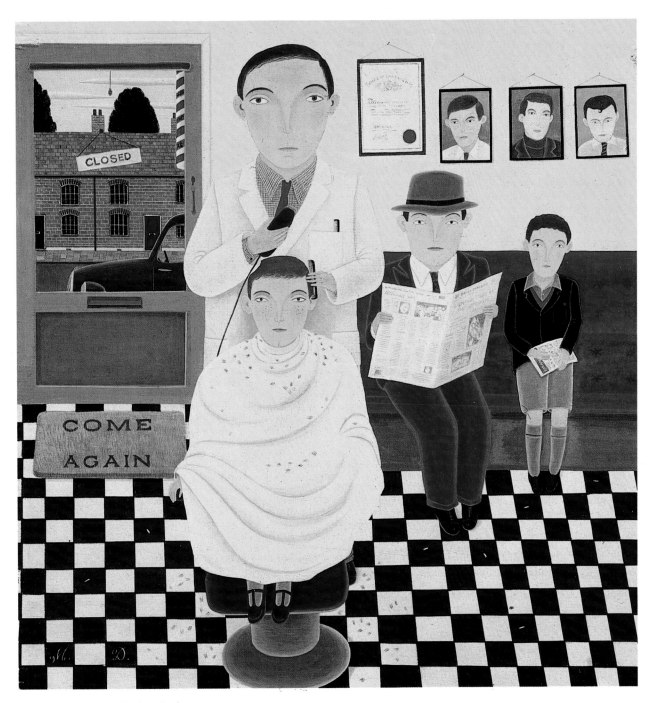

Mike Dempsey *Short back and sides*

Janet Woolley

1952

Janet Woolley was born in Plymouth. She always wanted to paint, and at the age of sixteen went to Shrewsbury School of Art. She later attended the Royal College of Art in London.

The first picture Janet can remember painting was of Christ on the cross, when she was about eleven years old. The painting was hung up at school, although when her family saw it, they thought it grotesque. Janet is now a full-time professional artist. She often works in the evening and at night as well as during the day at her home in Highgate, London, where she lives with her husband and daughter. Using acrylic paint and crayons, she draws straight on to board, then continues drawing and painting as she progresses over the picture. Her paintings are very detailed but on a large scale. Her decorative figures seem theatrical to her, like figures on a stage, and she enjoys the freedom to design the fabrics and costumes that they wear.

Janet Woolley's paintings have appeared in many magazines including the *Radio Times*, *Sunday Times*, *Observer*, *Esquire* and *Honey*. She has not yet had a one-man show, but her paintings have been hung in the Royal Academy Summer Exhibition, the Portal Gallery and the Thumb Gallery, London.

Janet Woolley *Cinderella* 1984

Index of Painters